HOW TO DRAW

Portraits

A STEP-BY-STEP GUIDE FOR BEGINNERS WITH 10 PROJECTS

SUSIE HODGE

NH
NEW
HOLLAND

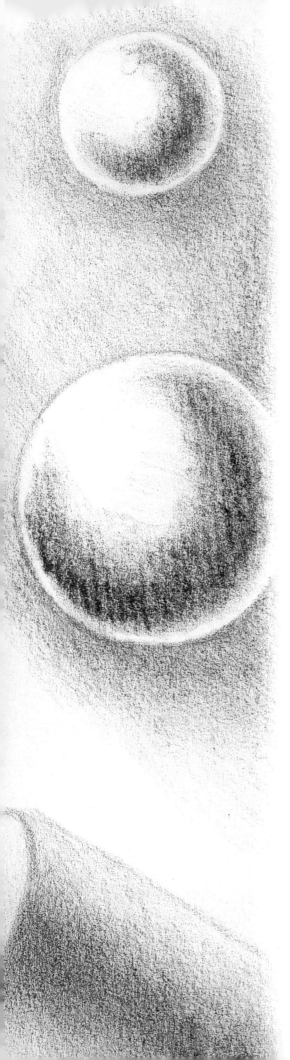

DEDICATION
To Katie and Jonathan.

First published in 2003 by
NEW HOLLAND PUBLISHERS (UK) LTD
London • Cape Town • Sydney • Auckland

Garfield House
86–88 Edgware Road
London W2 2EA
www.newhollandpublishers.com

80 McKenzie Street
Cape Town 8001
South Africa

Level 1, Unit 4
14 Aquatic Drive
Frenchs Forest, NSW 2086
Australia

218 Lake Road
Northcote
Auckland
New Zealand

10 9 8 7 6 5 4 3 2 1

ISBN 1 84330 381 7

Senior Editor: CLARE HUBBARD
Design: BRIDGEWATER BOOK COMPANY
Photography: SHONA WOOD
Editorial Direction: ROSEMARY WILKINSON
Production: HAZEL KIRKMAN

Reproduction by Pica Digital PTE Ltd, Singapore
Printed and bound by Times Offset (M) Sdn. Bhd., Malaysia

NOTE
Every effort has been made to present clear and accurate instructions.
Therefore, the author and publishers can offer no guarantee or accept
any liability for any injury, illness or damage which may inadvertently
be caused to the user while following these instructions.

ACKNOWLEDGEMENTS
To Rosemary and Clare for being empathetic, enthusiastic and
understanding. To Shona, for being such an outstanding photographer
and now, friend. To the designers for their marvellous work. To everyone
who appears in this book: Katie, Jonathan, John, Sue, Peter, René,
Whitney, Paris and Billy. To Tony Cook for his photographs for
demonstrations 6 and 9. And to my family for all their support.

Contents

Introduction

As the foundation of all other art forms, drawing is one of the most satisfying ways of expressing yourself. Many people believe that drawing is a skill you're born with and that it can't be learnt; luckily this is a fallacy. Another belief is that drawing portraits is more difficult than drawing anything else. Again, not true! It just takes the right approach.

Faces fascinate us and making images of ourselves is part of human nature. So how can you achieve a good likeness? How do you use pen and ink, coloured pencils, charcoal or Conté sticks? How do you make flat drawings look three-dimensional? This book gives you the answers to all these questions and more. It explains the craft – or the mechanics of drawing portraits – as well as the art and how to achieve quality of style.

Fear of failure holds most of us back on the path to good drawing. Too many of us have little confidence in our creative abilities. But, just as you learned to write, so you can learn to draw. It's a question of looking and making marks without any preconceptions. You don't have to draw in a particular way, try out different ways of working.

In the 2,000 years that portraiture as we know it has existed – an attempt to capture a likeness – ideas have been abandoned and reinvented many times. The ancient Greeks produced portraits of perfection and the Romans took this a stage further, flattering their dignitaries with idealized bodies, but realistic faces. The fall of the Roman Empire saw a decline in education and no one produced portraits for centuries. Then, early

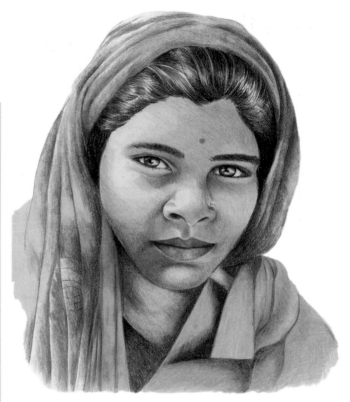

ABOVE Try to overcome any thoughts of "I can't do that" – you can! Once you start, you can only improve.

Renaissance artists produced profile portraits after discovering ancient Roman coins.

As an understanding of perspective developed, the three-quarter view became fashionable for Western portraits. Around that time, Leonardo da Vinci and some of his contemporaries studied anatomy. Their portraits show an understanding of the bone and muscle structure of the face in a way that few artists achieved before them.

By 1839, the invention of photography contributed to changes in portraiture. Some artists began using photography as an aid to their work. Some years later, artists such as Hénri Matisse and Pablo Picasso used distorted lines and shapes to convey ideas beyond the straightforward lifelike portrait.

Using the Book

The 10 step-by-step demonstrations show various people drawn in different media. The steps clearly explain and illustrate different stages in the drawing's progress, with tips on handling materials, subjects and situations and how to work from photographs or from someone sitting in front of you. The absolute beginner may find it more straightforward to begin with Demonstration 1 (pages 18–23), but you may prefer to dip in wherever you please. Each demonstration also features an alternative drawing of the same subject but produced in different materials and a photograph of the model in an alternative

pose for you to use as a reference for a new drawing. If you begin by copying the portraits in the book you will learn how to produce your own in similar poses with similar materials. Don't be intimidated by the finish of some of the portraits – they are there to show how far you can go with time and patience. It is perfectly valid to draw each portrait without including every variation in tone or detail. Don't be disheartened if you make mistakes when you begin. As you work, you will naturally improve and, once your confidence has grown, try out your skills on whoever will sit for you.

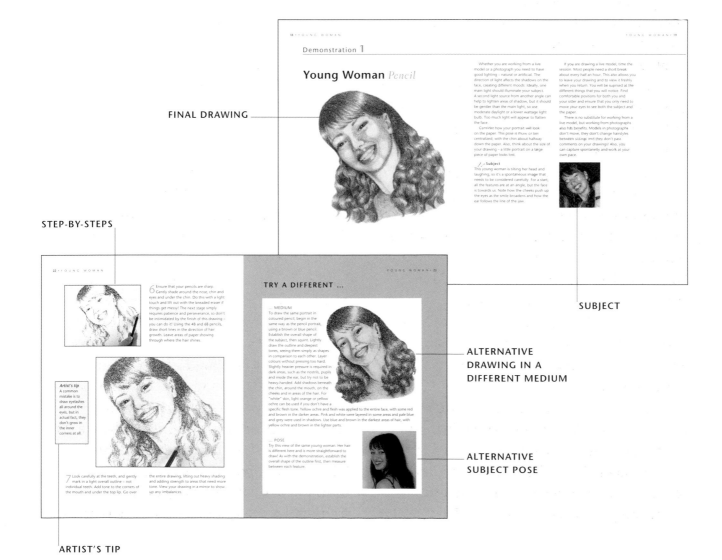

FINAL DRAWING

STEP-BY-STEPS

SUBJECT

ALTERNATIVE DRAWING IN A DIFFERENT MEDIUM

ALTERNATIVE SUBJECT POSE

ARTIST'S TIP

Tools and Materials

Pencils and paper are the most straightforward materials to begin with. You will soon find that you want to try out different techniques and new materials, but avoid unnecessary expense and disappointment by buying moderately at first. Begin with a medium that appeals to you and phase in others gradually as you feel the need to broaden your range and refresh your approach.

Quite soon, you will find yourself looking at people with an artist's eye: "What shape are those eyes, how would I render that hair?", so, keep a pen or pencil and sketchbook handy to jot down visual notes wherever you may be. Remember that no one has to see these sketches – they're your own private workings to help develop your eye. Also, try out ways of showing tones using different materials.

PENCILS These are made of graphite and clay and come in different grades of softness, indicated on the pencil itself. "H" stands for hard, "B" for black, meaning soft, and "F" for fine. "H" pencils (2H, 3H and 4H, they progressively become harder) will scratch into the surface of your paper and are not effective for tonal work. HB pencils are medium-soft. Aim to use a 2B or 3B to start your drawing and switch to a softer – or blacker – pencil, such as a 6B or a 9B, for deeper tones. Mechanical pencils are good for precision work but the softest grades are difficult to find.

GRAPHITE STICKS These are made of solid graphite usually without a pencil casing, so the side as well as the tip can be used. Thin graphite sticks often have a lacquer coating. Water-soluble graphite pencils can be blended with water on the page with a brush. They are effective for sketching and blending tones.

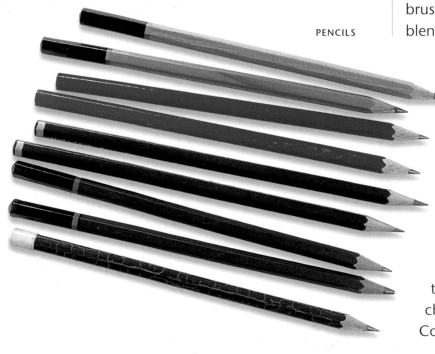

PENCILS

WHITE CHALK Available as hard sticks for detail and fine marks, or you can use soft pastels which are easier for blending.

CHARCOAL and CHARCOAL PENCILS These are essentially charred wood (willow or vine) and are one of the oldest drawing materials. Charcoal comes in sticks of different thicknesses – thin is good for portraits and block charcoal is good for oversize work. Compressed charcoal is heavier and

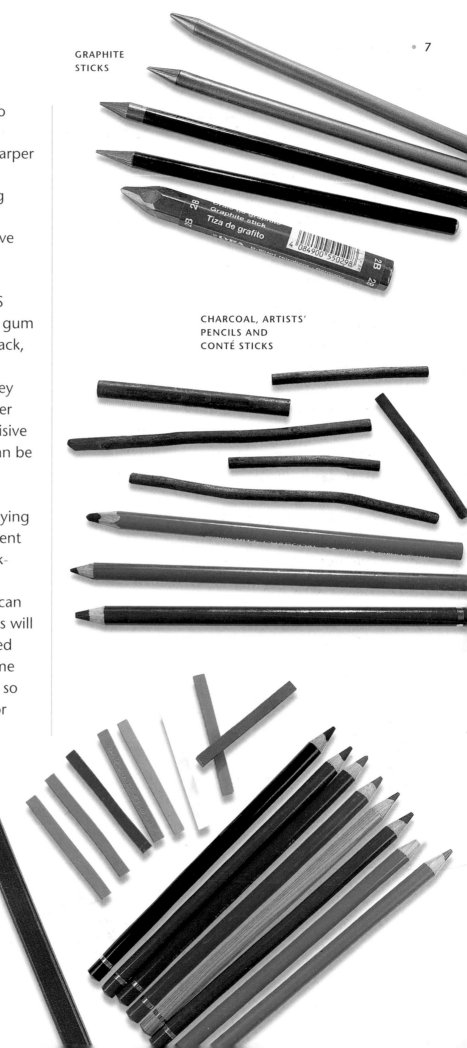

GRAPHITE
STICKS

CHARCOAL, ARTISTS'
PENCILS AND
CONTÉ STICKS

COLOURED AND
PASTEL PENCILS

produces a darker line that is not easy to smudge. Charcoal pencils have a wood casing, are less messy and can give a sharper line, but they are less easy to erase than ordinary charcoal. Use them for creating contrasts and rich tonal areas. Charcoal drawings need to be sprayed with fixative to preserve the finish.

CONTÉ CRAYONS, STICKS and PENCILS
These are natural pigments bound with gum Arabic. The most popular colours are black, white and browns, rusts and reds – particularly sanguine and sepia – but they are also available in a wide range of other colours. They are effective for crisp, decisive lines and for areas of solid tone. They can be smudged, but are not easily erased.

COLOURED PENCILS These come in varying qualities and softnesses and many different forms: standard, water-soluble and thick- and thin-leaded. Some coloured pencils make sharp, definite lines, while others can be blended more easily. Layering colours will produce different shades and unexpected results can be achieved by using the same group of colours in different sequences, so experiment to find out the best order for a particular shade. Some useful colours for portraits are: yellow ochre – a brownish yellow, raw umber – an orange-brown, flesh, vermilion (red), warm grey and burnt sienna – a dark brown.

PENS Technical pens are convenient for fast sketches, but their nibs make unvarying marks, so you need to practise making hatched, cross-hatched or stippled marks. Dip pens are penholders with interchangeable flexible metal nibs. Pointed nibs are best for portraits, although chiselled or calligraphy nibs can produce interesting results. Fountain or cartridge pens, roller ball, fine liners or specialist art pens are also versatile; they are available in different nib widths and can create fine, flowing lines. Ballpoint pens are available in several colours and widths of nib. They can be smooth and satisfying to use and are convenient for sketching.

INKS Water-soluble ink can be diluted with water and blended to depict tones. Waterproof ink is useful for drawing but will clog reservoir pens. Felt- and fibre-tipped pens come in both waterproof and water-soluble versions. Look around for different types of ink in various rich colours.

PENS AND INK

SHARPENERS A craft knife is good for sharpening pencils and trimming dirty edges from erasers. Use either a fixed blade or a retractable blade. Using a knife rather than a commercial pencil sharpener allows you to get the tip of your pencil exactly as you want it. If you do use a pencil sharpener, always ensure that the blade is sharp.

ERASERS and STUMPS A plastic eraser removes stubborn pencil or graphite marks on drawings and can be used to adjust small errors. When the end becomes dirty or worn, trim a sharp edge with a craft knife.

A kneaded eraser or putty rubber is good for manipulating into small shapes for hard-to-reach places and to "lift out" highlights. Its tacky composition can be used to "lift out" areas of pencil, charcoal, conté or chalk.

For blending charcoal and chalks use a torchon or tortillon, which is a paper stump.

FIXATIVE To prevent drawings made with pencil, charcoal or other soft pigment materials from being smudged they need to be fixed. Fixative is made by dissolving a resin in a colourless spirit solvent. It is sprayed onto the drawing and as the spirit solvent evaporates a thin coating of resin is left behind and binds the pigment dust to the support. Bear in mind that, once fixed, the drawing cannot be altered by using an eraser. You can, however, work on top of a fixed drawing and it is common practice to fix a drawing periodically whilst it is being made. Fixative is best applied using a CFC-free aerosol, following the manufacturer's instructions.

Bottles with a hand-operated spray and a mouth-spray diffuser are also available.

PAPER AND SUPPORTS The surface of the paper determines the effect of the media used on it. Good quality paper is neutralized to counteract acidity and will not become brown or brittle. It is usually labelled "acid-free". Store it in a dry place and don't keep it in acidic wrapping. Try out textured, coloured or hand-made papers to see what different effects you can create.

Cartridge (standard drawing) paper is the type of paper most often used for drawing on. It can be white, cream or coloured and is available in various weights, sizes and qualities. Buy the best cartridge paper you can afford and don't assume that drawing on a small piece of paper is easier – it's not!

Pastel paper comes in a range of subtle tints with a "tooth" or grain. One side is always textured in a particular way depending on the make. It's not incorrect to use the "wrong" side if you prefer. It is available in two weights – thicker, heavier paper can take more rubbing and reworking than lighter paper.

Watercolour paper is available in various weights. Hot pressed (HP) paper has a smooth surface, suitable for detailed work. "NOT" or cold pressed paper has a slight "tooth".

Sketchbooks are made in all surfaces, many sizes and both portrait and landscape formats. Pocket-sized books can be carried anywhere, but may be restrictive when you're tackling larger subjects. Big sketchbooks are tiring to hold, but offer adaptable space, with the option of making several studies on one page.

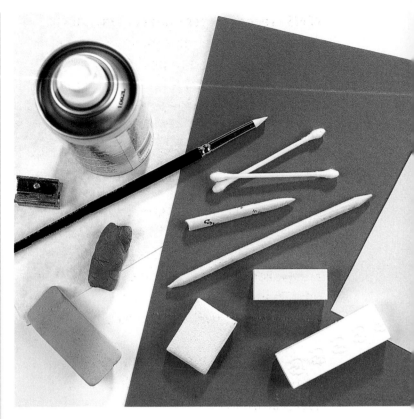

SHARPENERS, ERASERS, STUMPS
FIXATIVE, PAPER AND SUPPORTS

DRAWING BOARDS and EASELS You will find it easier to work if you secure your paper or support to a drawing board. Make sure the board is large enough to take the size of paper you will be working on and has a smooth surface. Secure your paper to the board with clips or masking tape. Either buy a purpose-made drawing board from a good art shop or use a sheet of plywood or MDF (medium-density fibreboard).

You may initially work with your drawing board propped on a few books or you may use an easel. The most important consideration, regardless of the size or type of easel, is stability. It must be strong enough to hold your drawing board and take any weight and pressure applied whilst working. A good choice is an adjustable table easel.

Basic Techniques

Many beginners find drawing portraits difficult because they can't capture the character of the subject. However, by training yourself to see the person objectively as a series of lines, shapes and tones, you'll be able to draw a convincing likeness. Most of us draw what we think we see, we believe that we are drawing what's in front of us. In actual fact, we're remembering symbols of what we think things look like.

Decide first of all which way to have your paper – upright in the traditional portrait style or sideways in landscape format. Consider the angle of view, how much of the person to include and the overall shape of your image. Before you begin, try making small sketches (thumbnails) to work out different compositions.

Look at your subject from different angles before you begin. Looking up from a low viewpoint has traditionally been used to make the subject seem important and powerful. Looking from slightly above is interesting or from the side, on a level with your subject. Look at successful portraits and ask yourself how the artists have composed them.

There are a few techniques that you should practise over and again in the way that a pianist practises scales. As you become more adept at them you will find that the portraits themselves become much easier.

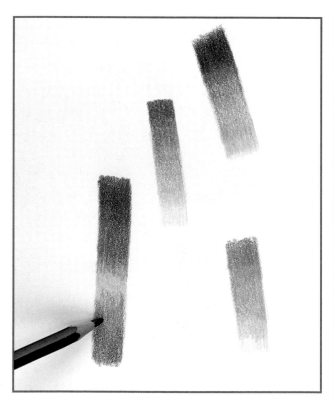

BLENDING

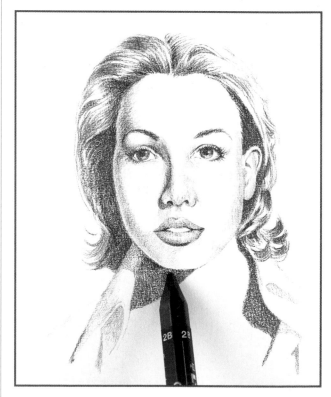

TONE (a)

BLENDING This is a way of achieving a transition from light to dark tone by smudging and rubbing the tone applied. The best materials to use for this are pastels, Conté crayons, charcoal and graphite. The softer the material, the easier it is to blend. You can shade colours into each other or burnish them by shading colours one on top of the other.

TONE (a) Fat graphite sticks are good for filling in blocks of tone. Keep looking at your subject to see where the dark, medium and light tones are.

(b) To show hair, use dark and lighter lines in the direction of growth. Don't try to show every hair, just direction and light, medium and dark tones.

(c) There are several ways of achieving gradations of tone. Hold the drawing implement – in this case a pencil – lightly and begin with light marks, then deepen the shading until it grows darker. Go over any areas that don't gradually change from light to dark. Or try hatching or cross-hatching.

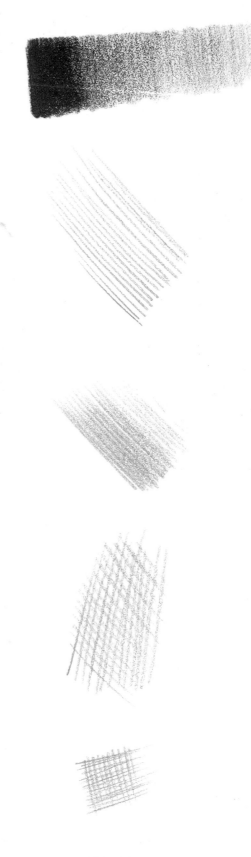

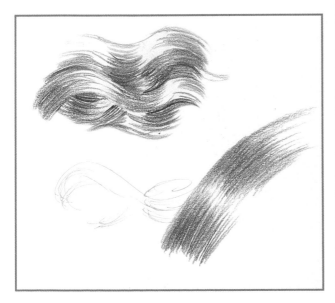

TONE (b)

TONE (c)

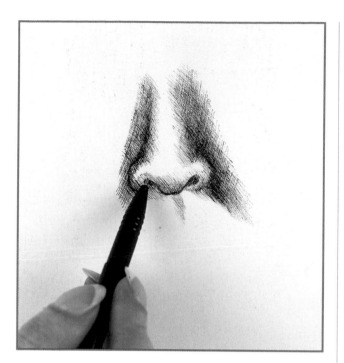

HATCHING AND CROSS-HATCHING

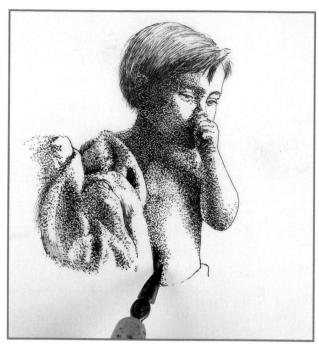

STIPPLING

HATCHING This is a method of applying tone using a series of parallel lines. The lines can be drawn close together for dense tones or spaced apart to create lighter tones. Curved lines can be used to represent wavy or curly hair.

CROSS-HATCHING This is another effective technique to show tone. Cross-hatching also uses parallel lines but more parallel lines cross them at an angle. It works particularly well with pen and ink.

STIPPLING This technique is also called pointillism – dots are placed close together or far apart to create dark and light tones. Entire portraits can be stipled with few or no outlines.

"LIFTING OUT" Use a plastic or kneaded eraser to "lift out" highlights on a drawing.

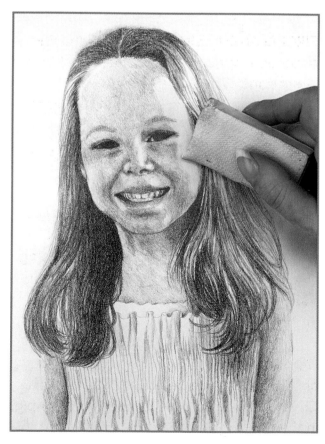

"LIFTING OUT"

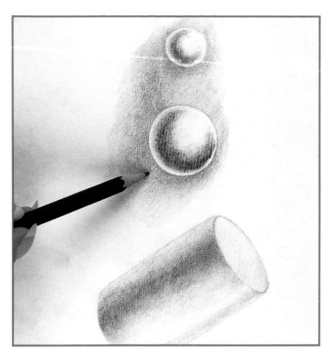

CIRCLES AND CYLINDERS

CAPTURING A LIKENESS

CIRCLES AND CYLINDERS Practise shading circles and cylinders to make them look three-dimensional. These shapes are the under-lying forms of the face. Note how the light creates tones on these shapes – fine rims of highlight are close to the darkest areas and the darkest tones follow the outer shape.

CAPTURING A LIKENESS Forget it's a person and draw and shade only the shapes you see. Create a "snapshot" image by cropping closely, e.g. cutting off the top of the head or shoulders and the mind will "fill in" the rest of the picture.

NEGATIVE SHAPES Be aware from the start of the negative shapes around your subject. Check them again as you finish. For example, in the drawing shown right there is a sort of triangle shape between the ear and shoulder.

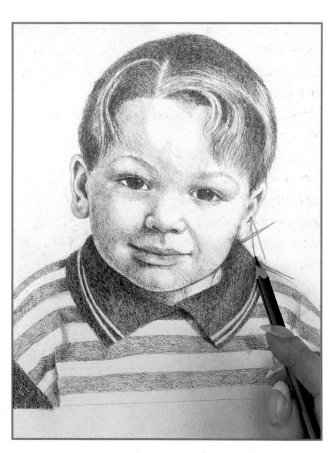

NEGATIVE SHAPES

COMPOSITION Consider how to compose each portrait. The picture below has been cropped in three different ways to show how different one pose can look, depending on how much you decide to draw and the way you place it.

Hints on drawing specific features

FACE (a) No facial expressions are more difficult to draw than others. Capture a mood by observing the shapes around the mouth, nose, cheeks and so on and squinting your eyes to see the tones.
(b) Through the underlying muscle structure, you can see how we purse our lips or raise our eyebrows, for example. This diagram will also help you to understand the planes of the face.

HAIR (a) Draw effective hair by using at least three or four different colours in streaks, drawn in the direction of growth. Leave areas of white paper showing through to

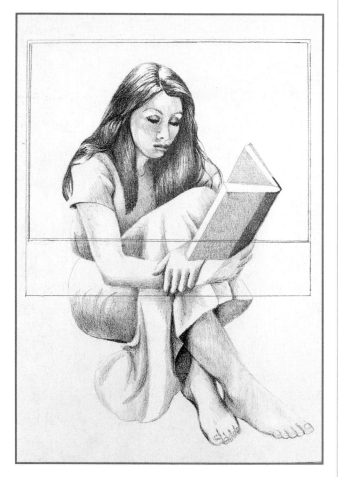

COMPOSITION

FACE (a)

indicate shine. Never try to show every hair, but indicate shape and tone, beginning with light marks, then darken with shading.

(b) Build up hair using hatched lines. Ensure that some lines are drawn close together while others are spaced apart to give a feeling of shine and density, building up a realistic image.

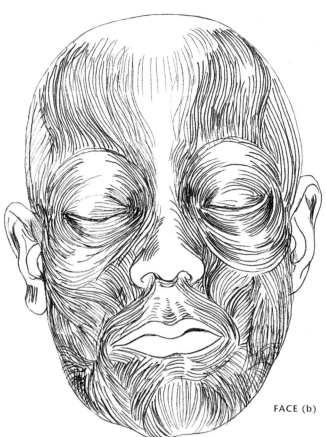

FACE (b)

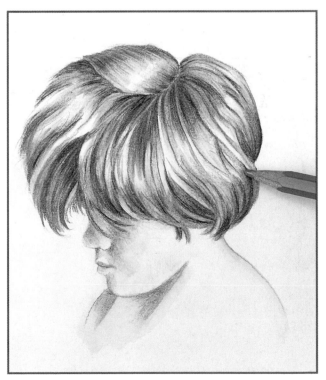

HAIR (a AND b)

**EYES – DIFFERENT SHAPES (a)
AND ANGLES (b)**

(a)

(b)

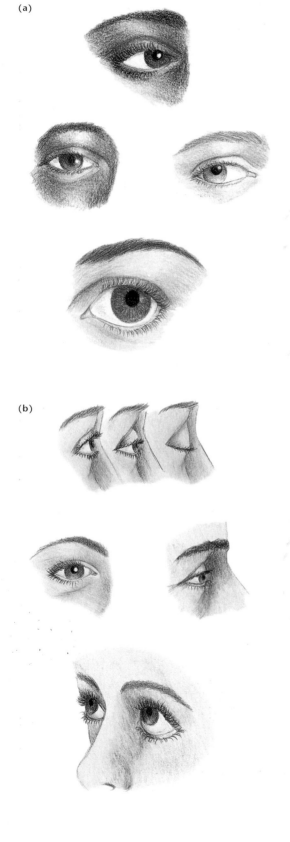

EYES

Eyes are often called windows to the soul. While it's important to get the eyes right, don't overwork them.

(a) Remember that eyes are balls under the eyelids, not flat shapes. The lids also usually cover the iris at some point – white showing all around gives a scared or surprised look.

(b) Become aware of how the shape of the eyes change as they are viewed from different angles.

NOSE Based on the length of the nose, most faces are divided into three parts: from the hairline to the top of the nose, the length of the nose itself and lastly, from the bottom of the nose to the chin. Although the nose is roughly triangular – unless in profile – don't draw lines to indicate either side, use careful shading instead.

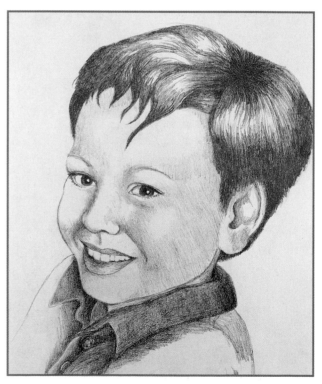

NOSE (a)

(a) Describe the shape and form of a nose by first marking on what you can see of the nostrils and base and then adding soft tones to the bottom and sides.

(b) A nose from the side can make or break a profile portrait. Check its shape carefully before you draw it.

MOUTH The mouth is an essential element in facial expressions. Under normal light, the top lip usually appears darker than the lower and the wavy centre line is usually darker still. Unless the person is wearing heavy lip liner, the lips are just a deeper shade of the skin tone with no harsh outlines.

(a) From the front, the mouth can be constructed out of a series of shapes.

(b) Mouths can look entirely different from different angles. Draw only what you see and never draw every tooth.

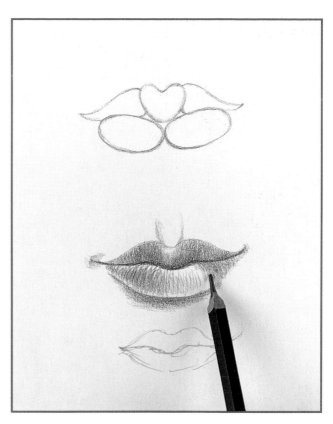

MOUTH (a)

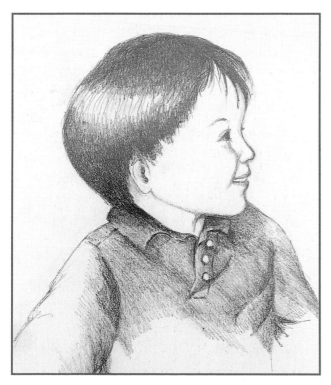

NOSE (b)

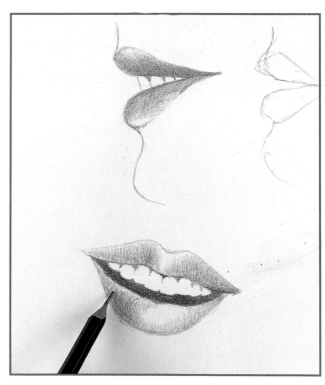

MOUTH (b)

Demonstration **1**

Young Woman *Pencil*

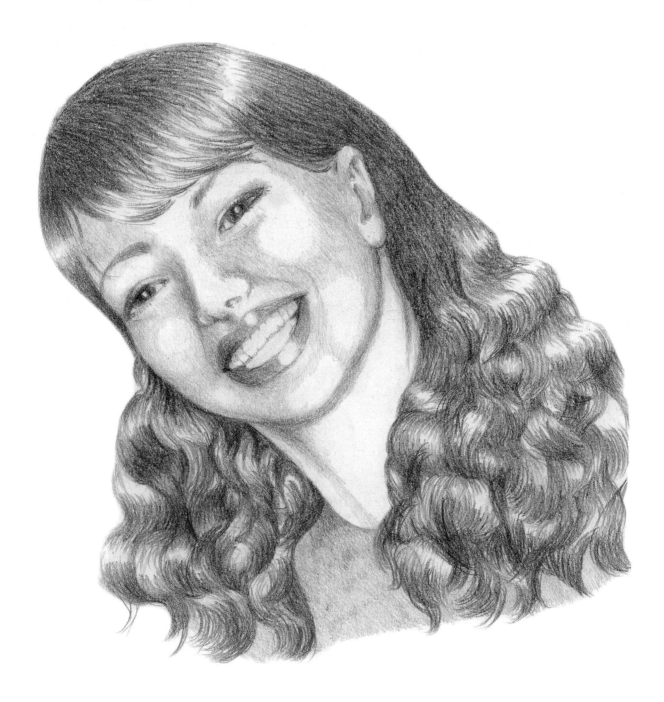

Whether you are working from a live model or a photograph you need to have good lighting – natural or artificial. The direction of light affects the shadows on the face, creating different moods. Ideally, one main light should illuminate your subject. A second light source from another angle can help to lighten areas of shadow, but it should be gentler than the main light, so use moderate daylight or a lower wattage light bulb. Too much light will appear to flatten the face.

Consider how your portrait will look on the paper. This pose is more or less centralized, with the chin about halfway down the paper. Also, think about the size of your drawing – a little portrait on a large piece of paper looks lost.

If you are drawing a live model, time the session. Most people need a short break about every half an hour. This also allows you to leave your drawing and to view it freshly when you return. You will be suprised at the different things that you will notice. Find comfortable positions for both you and your sitter and ensure that you only need to move your eyes to see both the subject and the paper.

There is no substitute for working from a live model, but working from photographs also has benefits. Models in photographs don't move, they don't change hairstyles between sittings and they don't pass comments on your drawings! Also, you can capture spontaneity and work at your own pace.

Subject

This young woman is tilting her head and laughing, so it's a spontaneous image that needs to be considered carefully. For a start, all the features are at an angle, but the face is towards us. Note how the cheeks push up the eyes as the smile broadens and how the ear follows the line of the jaw.

Materials

2B, 4B and 6B pencils

*Sheet of cartridge (drawing) paper
420 x 297mm (16½ x 11¾in)*

Kneaded eraser

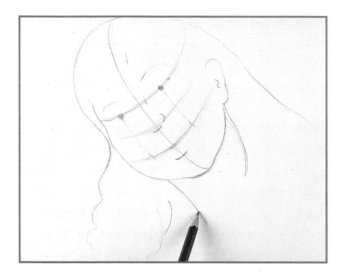

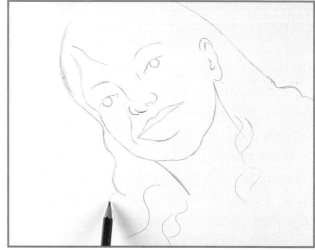

1 Before you begin drawing, study the subject to gain as much information as you can; for instance, the shapes of the chin, nose and hair and the angle of the eyes and ears. Look at the negative shapes of the entire outline and then visualize it on the paper. With a 2B pencil, mark the top of the head and the chin. Lightly mark in guidelines for the eyes, nose and mouth. The eyes are about halfway between the top of the head and the chin and the base of the nose is halfway between the eyes and chin. The pupils are vertically above the corners of the mouth. Roughly draw in the shapes of the chin, the bottom of the nose and the eyebrows.

2 There is about one eye's gap between the eyes. Lightly draw the shape of the upper eyelid and the circles for the irises. Mark on the nose and mouth. To establish exact positions and proportions, sit upright, stretch out your arm holding your pencil and close one eye. Place the top of your pencil in line with the top of the part you are measuring and slide your thumb down to align with the bottom of what you are measuring. On the paper, multiply this length however many times you need to in order to establish a size. Mark each measurement as you work and continue measuring in this way for all significant points. Keep your back and arm at constant right angles when measuring this way.

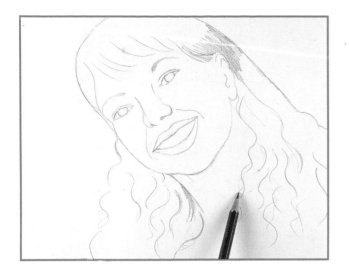

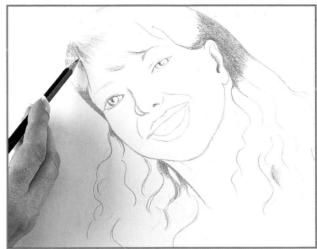

3 Using only lines, draw in the features, including more squiggles for the hair. Keep checking and measuring the spaces between the features.

Half-close your eyes and look at your subject so that you only see the darkest and lightest areas. Find the darkest areas and, using the 4B pencil, begin shading with gentle pressure and no smudging. To stop the paper showing, shade with close hatched lines or ellipses. Adjust your pencil pressure to build on the tones, but don't press too hard. You will find drawing easier if you hold the pencil further back than when you write.

4 More than any other feature, the eyes show a person's character and mood. They are the focal point of the face. Draw the shapes of the whites first – in this case, the smile is creasing the eyes so there is little white on show. Add some tone to the irises and pupils. Gradually build up the darkest tones in the hair, using the 6B pencil. Lips are just a dark shade of skin, so soften any heavy outlines. Don't try to include every strand of hair but add tones where you see them to build up the overall look.

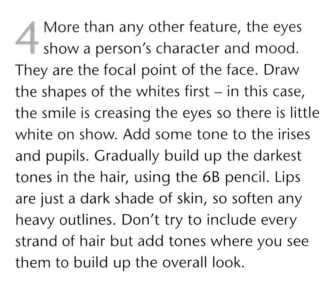

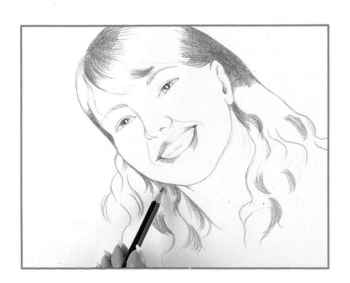

5 Lightly add shadows to the eyes under the top lids. The curve of the eye can pick up direct and reflected light, so watch for the highlight and leave a spot of paper showing through on the pupils. Use gentle shading at the sides of the nose to indicate form. Never use heavy outlines around features. If you have over-shaded any areas, lift them out with the kneaded eraser by pressing and releasing it. Squash the eraser into whatever shape you need; such as a fine point to make highlights on the eyes.

6 Ensure that your pencils are still sharp. Gently shade around the nose, chin and eyes and under the chin. Do this with a light touch and lift out with the kneaded eraser if things get messy! The next stage simply requires patience and perseverance, so don't be intimidated by the finish of this drawing – you can do it! Using the 4B and 6B pencils, draw short lines in the direction of hair growth. Leave areas of paper showing through where the hair shines.

Artist's tip
A common mistake is to draw eyelashes all around the eyes, but in actual fact, they don't grow in the inner corners at all.

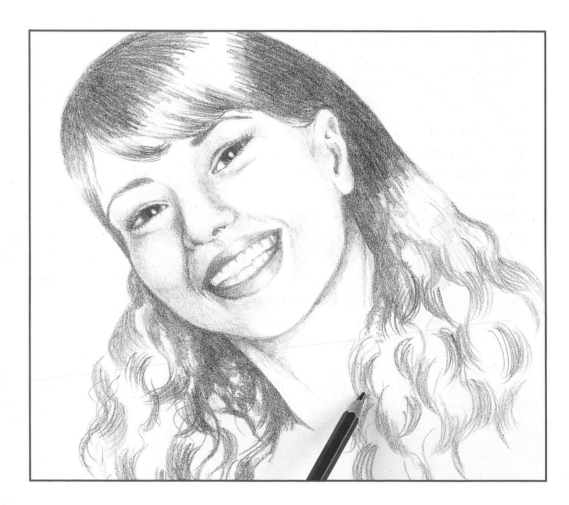

7 Look carefully at the teeth, and gently mark in a light overall outline – not individual teeth. Add tone to the corners of the mouth and under the top lip. Go over the entire drawing, lifting out heavy shading and adding strength to areas that need more tone. View your drawing in a mirror to show up any imbalances.

TRY A DIFFERENT ...

... MEDIUM

To draw the same portrait in coloured pencil, begin in the same way as the pencil portrait, using a brown or blue pencil. Establish the overall shape of the subject, then squint. Lightly draw the outline and deepest tones, seeing them simply as shapes in comparison to each other. Layer colours without pressing too hard. Slightly heavier pressure is required in dark areas, such as the nostrils, pupils and inside the ear, but try not to be heavy-handed. Add shadows beneath the chin, around the mouth, on the cheeks and in areas of the hair. For "white" skin, light orange or yellow ochre can be used if you don't have a specific flesh tone. Yellow ochre and flesh was applied to the entire face, with some red and brown in the darker areas. Pink and white were layered in some areas and pale blue and grey were used in shadows. Use blue and brown in the darkest areas of hair, with yellow ochre and brown in the lighter parts.

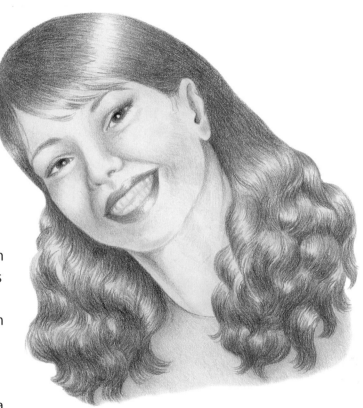

... POSE

Try this view of the same young woman. Her hair is different here and is more straightforward to draw! As with the demonstration, establish the overall shape of the outline first, then measure between each feature.

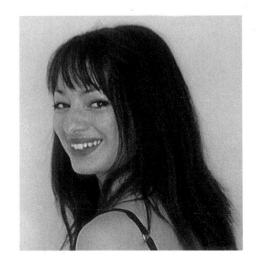

Demonstration 2

Baby *Pencil*

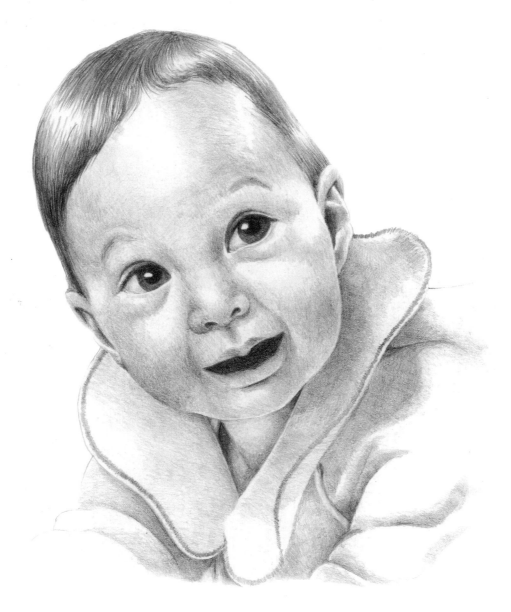

It is a myth that babies are harder to draw than adults. Apart from the fact that a baby probably won't keep still for you, as a subject they are no harder to draw than any other portrait subject. As always, the problem is not drawing, but seeing. Concentrate on drawing only what you see, not what you think you see.

Practising drawing babies is an ideal opportunity to use your sketchbook. You will gain a lot from several quick sketches made as babies move or sleep, whether they are newborn, a few months old or toddlers. Look at how the features change as the baby gets older. Don't try to draw perfect pictures, just note down a few essential lines to understand angles, proportions, features or expressions. Fill a sketchbook with these visual notes, however inaccurate or unfinished. Look out for characteristic gestures and just jot down a few lines. By the end of the sketchbook you will have learned a lot. You can always draw a sleeping baby. No matter how lively they are when awake, most babies are picture-perfect when asleep.

Subject

Below the nose, babies' faces are smaller than adults' due to lack of development in the upper and lower jaws. Their heads are larger in comparison to this lower area, due to the development of the cranium, which is accommodating the fast-growing brain. Whereas adults' eyes are approximately halfway down the head, babies' eyes are closer to the chin. Their jaws are smaller than adults' jaws and their cheeks and foreheads are more rounded.

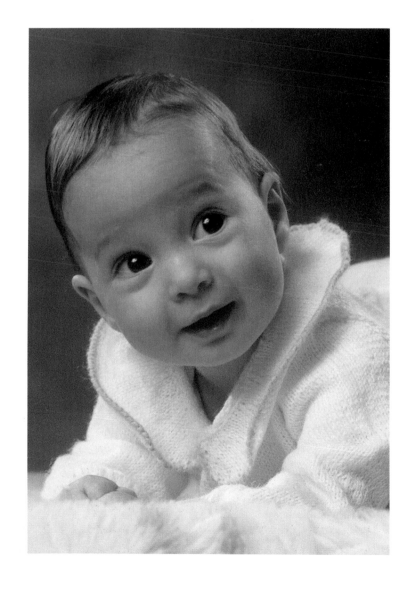

Materials

2B, 3B and 4B pencils

Sheet of cartridge (drawing) paper 420 x 297mm (16½ x 11¾in)

Kneaded eraser

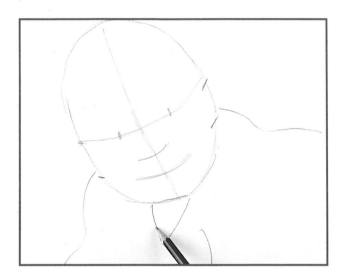

1 Look carefully and visualize the outline on your paper. With the 2B pencil, roughly draw the outline of the head, neck and back. Mark on the central axis of the face, noting that the bones of the skull curve. The measuring technique described in Demonstration 1 (see page 20) is helpful, but here are a few basic baby proportions as well. A baby's eyes are about halfway between the top of the head and the bottom of the chin. If you mark horizontal lines to divide the space between the eyes and the chin into three equal parts, the eyes rest on the first line, the nose ends on the second line and the lower lip rests on the third line.

Artist's tip
Remember that essentially the head is a sphere shape – not flat – so make sure that guidelines curve around the head.

2 Continue to loosely define the features. Begin to draw outlines for the eyes, trying to ensure that they "match" – you can always adjust them as you go along. Start to indicate the base of the nose, the ears and the mouth. Begin drawing the collar and roughly indicate the position of the arms. Erase the guidelines as soon as you are happy with the shape, position and proportion of the features.

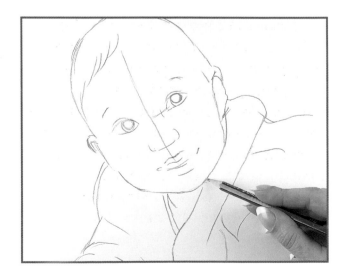

3 Draw the features more carefully. Check the angles and shapes of the eyes, eyebrows, ears, mouth and so on. Draw in details, such as the pupils, nostrils and the inside of the mouth. Shape the collar and mark on a few lines to indicate the hair. The eyebrows are much lighter than the eyebrows on an adult. Start to mark on some wisps of hair, the nose to mouth lines (lightly) and the shapes within the ear.

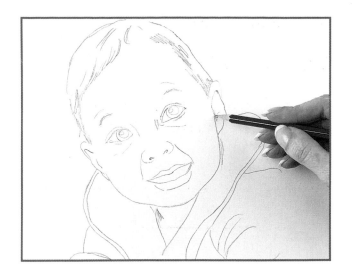

4 Shade the inside of the mouth, the nostrils and the pupils with the 3B pencil. Remember that the eye socket is a circle into which the eyeball fits comfortably. You can still adjust any mistakes with the eraser. Also, note that even babies have little creases around the eyes, but don't be too heavy-handed with these – mark them in gently. Using the 3B pencil, add more strokes to the hair – keep these in groups to indicate darker areas.

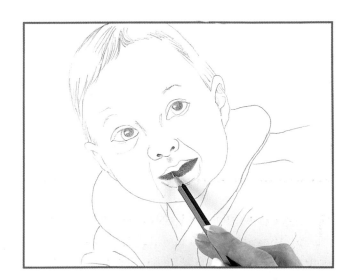

5 Shade some more of the hair, using hatched lines in the direction of growth. Use a sharp pencil and gentle pressure. Gently shade around the bottom of the neck. Although you need to make the mouth clear, never give a baby lip liner! Note where any highlights fall and leave the paper showing through. Shade in the ears. Note that the top lid creates shadows on the eyeball. Make the iris and pupil darker at the top.

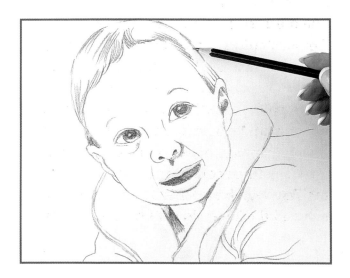

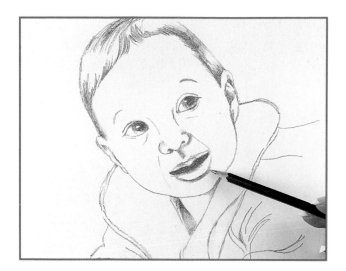

6 Look for the dark areas on the hair and add darker tones. Use directional strokes with the pencil – in the direction the hair grows – and don't attempt to draw in every hair. Look for other shapes of the shadows – around the nose, under the chin, below the mouth and the irises – and shade them more carefully with the 4B pencil.

7 Now begin to shade across all areas where you see tone. For example, around the mouth and cheeks, where you see shadows in the folds of the clothes and on the cheeks themselves. Refine the hair with sharp pencil strokes. Look closely at negative spaces as well as positive shapes. Continue to gently shade across the paper, squinting to ensure that you get all the dark and light shades in the correct places. Leave the lightest areas as the white of the paper – babies have smooth skin with little variation in tone, compared to an older face. If you have been overzealous with tones, lift out the dark areas with a kneaded eraser.

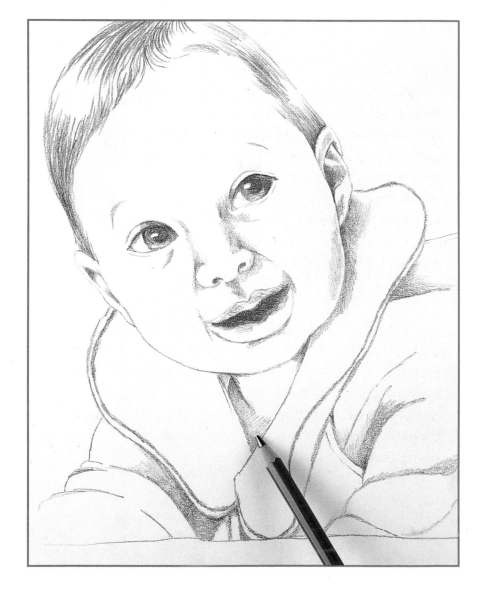

TRY A DIFFERENT ...

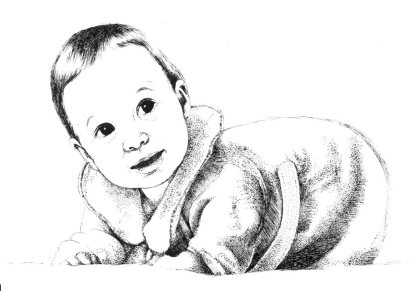

... MEDIUM

To produce the same portrait in pen and ink you need to use different rendering techniques because pen and ink cannot be varied, unless mixed with water. One of the hardest things is to know when to stop. Draw the outline of the baby's face lightly in pencil. Load the dip pen with ink, wiping any surplus off on the side of the bottle. Lightly draw short lines to mark in the darkest areas. Get into the habit of using broken lines. The closer the lines, the denser the tone. The tones here are mainly achieved using stippling which requires patience and a fairly steady hand. Finish before you feel you should, as you can always add more at a later stage when you have a chance to look at it with fresh eyes. It's easy to add more marks, but you can't take any away.

... POSE

This lively little lady is an interesting subject. Before you start to draw this portrait, decide what makes the face look so amused – it's a mixture of the eyebrows, the mouth and the shapes of the eyes. Keep thinking in terms of shape and tone.

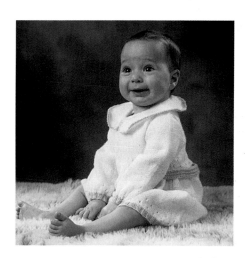

Demonstration 3

Mature Man *Pencil*

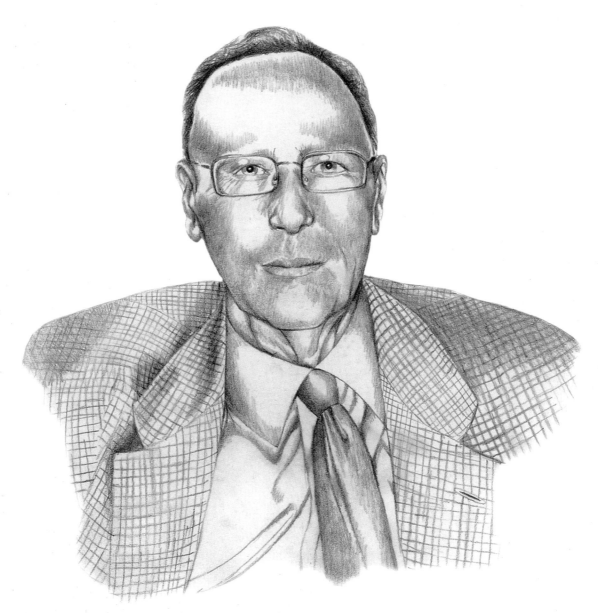

As we age, our personalities begin to show on our faces as the muscles habitually form certain expressions, skin softens and gravity pulls some of the tissues down. Although we live in a youth-orientated society, expression lines add something to a face.

As with all portraits, lighting is important. Lighting helps to make the portrait

interesting or dull and it can set the place and mood. If you're working with light from north-facing windows, your model can sit almost anywhere and the portrait will always be well lit. If not, you need to use artificial light from the back, which will minimize any harsh shadows.

Although it is best to work from a live model, photographs are also valuable aids.

Copy pictures from magazines and/or your own photographs to capture the fleeting expressions that might be difficult to draw from life. Use these images to develop your sense of tone. This is where a sketchbook comes in handy – make quick sketches of people you see, magazine pictures and your own photos until you become used to facial expressions, proportions and tones.

Subject

Look closely to find qualities that convey your sitter's personality – perhaps a twinkle in the eyes, laughter lines around the mouth or an air of serenity and wisdom – but be careful not to exaggerate and turn your drawing into a caricature. This subject was lit from behind and above.

Note that there are few hard lines in the image – only really the collar, jacket and tie. Even the glasses are fairly "soft". To see where the dark and light tones fall, half-close your eyes to shut out most of the colour and see the subject clearly in tonal contrast. For a looser, sketchier portrait, use either hatching or cross-hatching.

Materials

2B, 4B and 6B pencils

*Sheet of cartridge (drawing) paper
420 x 297mm (16½ x 11¾in)*

Kneaded eraser

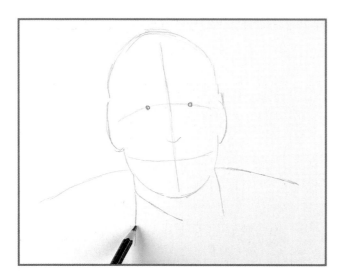

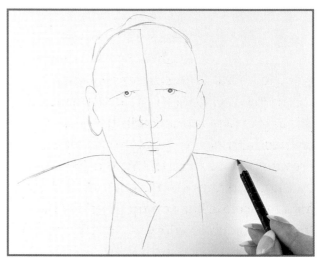

1 The man is looking straight ahead. Mark the outline by drawing the negative shape of the head and shoulders and indicate the collar. Note how wide the shoulders seem because of the jacket. Lightly mark in the positions of the features. Notice the size of the ears (our eyes stay the same size from birth, but our ears and noses continue growing). Make sure that the features curve around the bony structure of the head. No distracting background has been included in this portrait.

2 Continue to shape the ears, the base of the nose and the mouth. Keep checking proportions, shapes and distances. Still using the 2B pencil, mark on the outline of the shoulders and hair. Study the curve of the eyelids. In this case, the upper lid is curved, but the lower lid is fairly straight. The eyes are essentially spheres embedded in the hollows of the eye sockets, although this is not clear in many people. Use the 4B or 6B pencil to shade the pupil as dark as possible, not forgetting to leave a white spot to show the highlight.

Artist's tip
Even if you can't see any highlights in the eyes, leave some to add extra depth and to lift the entire face.

3 To draw the glasses, don't draw what you imagine glasses to look like but look carefully at the dark and light shapes. Check the angle of the eyes in comparison to the cheek and the nose. Ensure that the upper lid is more curved than the bottom and lightly draw the shape of the lips. Mark on some neck lines, the collar, tie and lapels of the jacket. Begin to erase the guidelines as you establish the correct shapes.

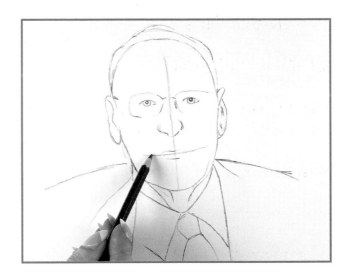

4 The nose is a bony wedge-shape protruding from the head. Remember this as you draw. Add details to the jacket, tie, neck and glasses. Using soft pencil pressure, shade some of the mid-tones or use hatching lines to indicate texture. Look for a few crease lines on the shirt and mark them on. Begin to add some of the detail on the ears.

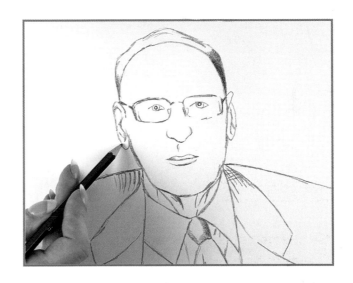

5 Continue to develop the features, such as the eyes, mouth and glasses. Add a few gentle laughter lines around the eyes and some more of the hair. Shade the tie some more and add more tones around the shirt and jacket. Note how deep the darkest shadows are and how they blend away to lighter areas. Mark on some of the check pattern of the jacket.

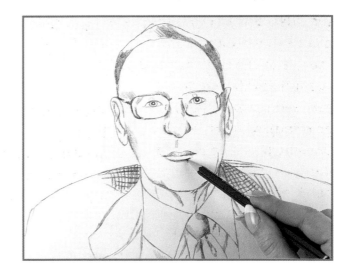

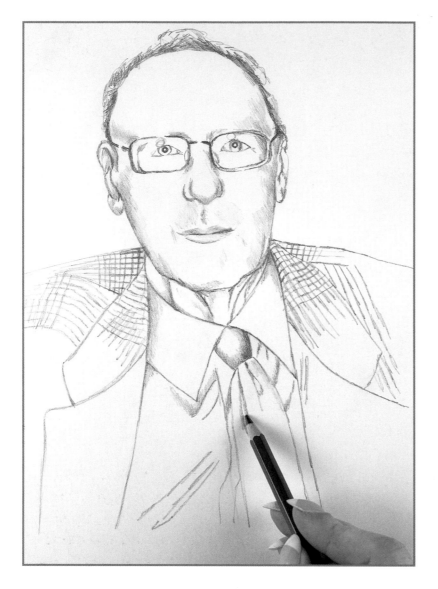

6 Continue marking in the hair and creases in the shirt, only adding darker pencil strokes where you see shadow. Switching to the 4B pencil, darken the largest dark areas. If necessary, use the kneaded eraser to lift out some of the highlighted areas. Begin to add some darker tones to the neck. Keep checking proportions, such as where the ears are in relation to the collar and where the eyes are in relation to the mouth. Adjust these where necessary.

Artist's tip

Glasses that correct long-sightedness can make the eyes appear larger. In order to avoid over-exaggerationg the features, draw eyes softly under them.

7 Define the shapes of the features a little more, working on all parts of the face at once, so you don't lose the balance. Habitual expressions create creases and laughter lines but they must not be drawn in too deeply. Gently shade the nose and around the chin. Draw details of the features and the hair with short, sharp marks. Add more pattern to the jacket, but don't worry about drawing every check – use artistic licence! Continue to add tones where you see them, such as on the clothing and around the chin, cheeks and ears.

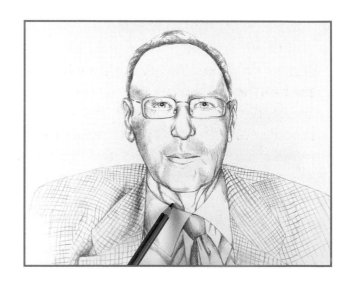

TRY A DIFFERENT ...

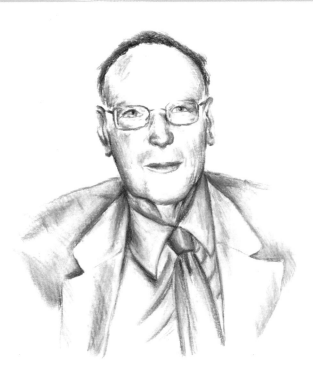

... MEDIUM

For this portrait, draw the rough outline with sepia Conté stick or crayon. Shade the mid-tones with sanguine and define the deepest tones in black. Soften some edges with your finger, a torchon or cotton bud or layer with white. Use a sharp point of the sepia stick to mark in details. Aim for an unfinished look with Conté, so keep everything light, as mistakes can be difficult to erase. Use the kneaded eraser or white to soften any over-shaded areas or where lines look too heavy. Allow the paper to show through as part of the portrait.

... POSE

Profiles are a good way of studying the proportions of the head as they are marked out clearly from this angle. To get these proportions right, focus on the negative spaces around the subject and draw those first, then look for the tones and shade carefully. For example, see how the chin relates to the nose and the shapes between the lips and chin. Notice also how the eyes appear from this angle.

Demonstration 4

Dark-skinned Man
Charcoal and chalk

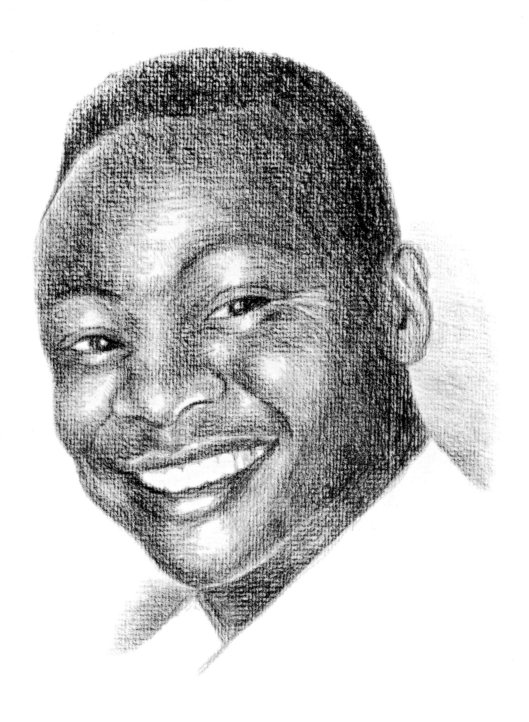

Charcoal is a wonderfully versatile medium. You can alternate from thin, flowing lines to broad strokes and build up areas of graded tone. You can block in large mid-tone to dark areas quickly using the side of the charcoal. Different effects can be achieved working on coloured, smooth or rough paper. However you use it, charcoal is quick and satisfying to work with, although it can be messy. Stand up and make large marks with it or work more closely on tonal depth and texture. The rich and subtle tones of dark skin can be wonderfully rendered using charcoal and white chalk. For this portrait, I used one main light source to accentuate the planes of the face. Be aware of these planes, whether you are working from a live model or a photo. Nothing can deaden a portrait more than a flat slab of tone across a face. Always look for highlights and dark tones, as these are what make the face look three-dimensional.

If you are working from a live model and your subject will sit for you on more than one occasion or you are working from a photograph, leave your subject for a day or so. By looking at it with a fresh eye, you will be able to re-evaluate all the shapes, angles, tones and proportions.

Subject

Dark skin usually has a wonderful sheen to it and charcoal, with its smudgy, immediate properties, is ideal for showing this. This man has a warm, invigorating smile that lights up his face even more. The emphasis on the planes of the face can be brought out with highlights on the prominent areas, such as the nose, chin and cheekbones. The secret here is to be sensitive to exactly where the highlights fall or you could change the character of the face, so use a light touch and be prepared to change everything if you make a few wrong marks.

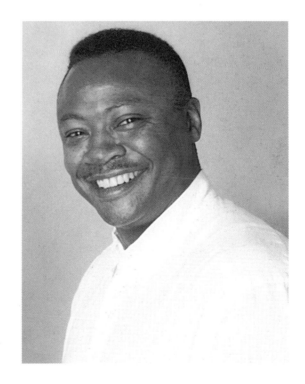

Materials

Fine willow charcoal

Sheet of cartridge (drawing) paper 420 x 297mm (16½ x 11¾in)

Torchon

White chalk

Fixative spray

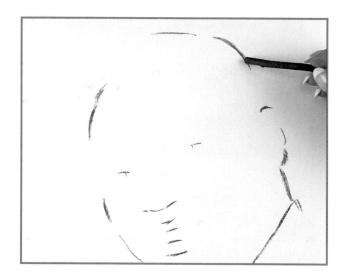

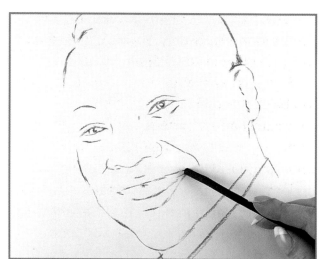

1 Lightly draw some marks to help with the proportions and positions of the main features. Be very light-handed with the charcoal. Try to stop thinking of the image you are drawing as a face, but see it in terms of lines, tones and shapes. For example, notice where the inner corner of the eye is in relation to the nose and mouth. This helps you to space everything correctly.

Mark on the angle of the collar and the general shape of the ear and head.

2 Really look at the shape of the whites of the eyes and how the eyelids curve. If you view the whites of the eyes as triangular shapes, you should achieve an accurate overall eye-shape. Note angles such as the nostrils and arch of the eyebrows. Draw these in lightly. Mark on the chin, hair and a more detailed ear shape and begin to draw the shape of the mouth. Indicate the nose to mouth lines.

3 Establish the correct shapes for the features and add details, such as the nostrils and pupils of the eyes. Look for the deepest tones and the brightest light tones by squinting at your subject. Start to shade gently in areas where you see the darkest tones. Don't try to draw every hair on the head, but begin to indicate it as a whole shape. Similarly, you don't need to draw every tooth. Simply indicate teeth by drawing the top of the gums and the shape of the bottom of the teeth.

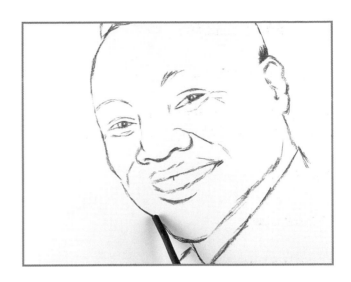

4 You can create a full range of tones with charcoal. Practise tonal scales in your sketchbook if necessary, shading from dark to light and vice versa. Shade around the neck, cheeks and nose. Take care not to press too hard. It is difficult to erase charcoal completely and incorrect marks can be confusing. Keep your hand high to avoid smudging or place a clean sheet of paper under your drawing hand. Begin to mark on the eyebrows. For the hair, draw circular marks over and over in the darkest areas.

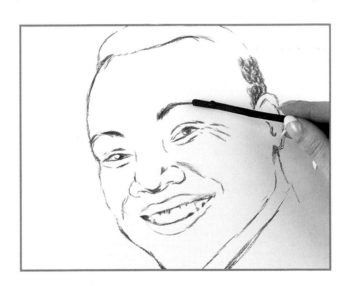

5 Continue to shade the darkest tones and with short, broken marks add details such as the inside of the mouth, the chin, pupils and bottom of the nose. Leave areas of clean paper where there are highlights, on the eyes, cheeks, chin and nose.

Half-close your eyes to see exactly where the darkest tones are. Continue building up the texture of the hair with scribbled marks. Build up the eyebrows with short dashes in the direction of growth.

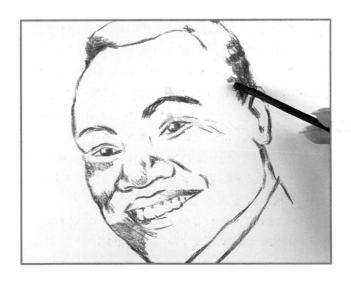

6 If you have worked lightly, stand back and evaluate what you have done. Are the dark areas in the right place and are they dark enough? Is the jaw correct? (Look at its angle compared to the edge of the shirt). Note the shape of the bottom of the nose and the space between the top lip and the base of the nose. Where do shadows appear around the mouth? On the chin? Under the nose? Mark all these in lightly. Begin to add some details to the ear. Soften some of the shading with a torchon.

7 Continue gentle shading over the softened marks with short, light strokes. Now emphasize the highlights with the white chalk. Half-close your eyes again to establish where the brightest highlights are and mark them in the shapes that you can see. Be aware of which areas are from direct and which are from reflected, light. Often, reflected light is not as bright as direct light.

Artist's tip
If you hold the charcoal quite far back, you will force yourself to press lightly, which ensures you don't shade too heavily.

8 You can go over some darker tones and make them lighter with touches of white chalk. Smudge this with the torchon if necessary. Again, a light touch is necessary – you can always add more. Hold the picture up to a mirror to check for any inaccuracies. Blow off any surplus dust and spray your portrait lightly with fixative.

TRY A DIFFERENT ...

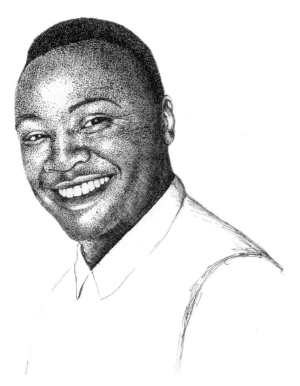

... MEDIUM

This pen and ink portrait is started in the same way as the charcoal portrait, but use a 2B pencil for the initial light outline. Mark on the top, bottom and sides of the head. Then begin to add details such as the shapes of the eyes with a dip pen and sepia ink. Note in which direction the eyes slant. Define the dark tonal areas and add more detail to the hair, mouth and eyes, using a mixture of hatching, cross-hatching and stippling. The darkest tones can be achieved by layering strokes or dots of ink for intensity. Leave the lightest areas without any pen marks at all – let the paper be the highlight. Make sure the roots of the hair are darker than the tips, using whichever rendering technique you feel is most effective. It depends on the look you want to produce, so practise different ways of working with the pen to see what you prefer. Here, for instance, several rendering techniques have been used. For a quicker, lighter portrait, you might only use hatching or cross-hatching.

... POSE

You might want to have a go at this pose, using whichever materials you prefer. Always look out for any negative space before you begin looking at tone and texture.

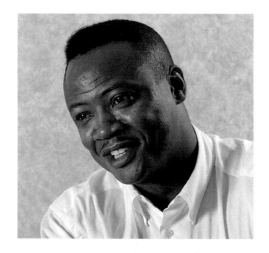

Demonstration **5**

Mature Woman *Graphite sticks*

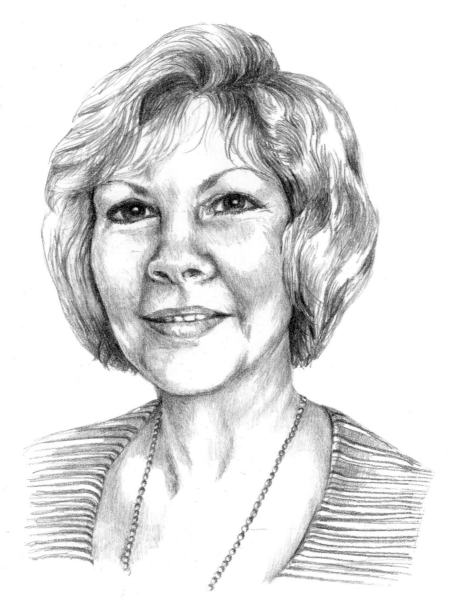

Graphite sticks are flexible to use and can be erased completely if necessary. So, you can be as adventurous as you like, knowing that any mistakes can be corrected. Start with a 2B graphite stick as it has a good texture, provides quick covering power and can be used expressively in a number of ways. Perfect for portraits!

As with all portraits, make sure that you have spaced everything correctly before you begin adding any detail. Use a light touch and be prepared to go over any lines that don't look right.

If you have got used to the idea of using a sketchbook, you will find that even a five-minute sketch of someone watching television or reading will help to improve your powers of observation. The aim is to gather information which can be used later.

To accurately capture the personality of the sitter you need to depict their expressions, gestures and clothes. Even a minimal suggestion of clothes can help to describe the person's shape and stance. Expressions are not difficult if you don't let any subconscious preconceptions take over. Look for shapes of shadows and notice subtle differences as an expression changes, such as a slightly raised cheek or eyebrow, or an upward tilt of the corners of the mouth.

Subject

As we mature, our skin becomes softer and the facial expressions of a lifetime begin to remain on the face. The subject of this portrait has a great sense of humour, which you can see around her eyes and mouth. It's a good challenge to try to bring out the three-dimensional personality on your two-dimensional piece of paper.

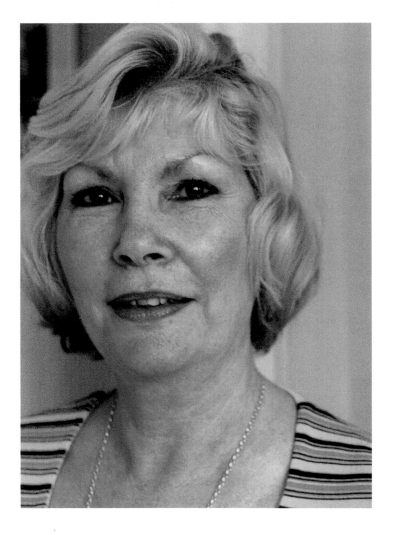

Materials

2B and 4B graphite sticks

*Sheet of cartridge (drawing) paper
420 x 297mm (16½ x 11¾in)*

Plastic eraser

Kneaded eraser

Fixative spray

1 Remember to look at the subject objectively and only draw what you actually see, not what you think you see. Begin with the 2B graphite stick, loosely sketching the overall negative shape of the head and shoulders. Note the width of the head in comparison to its height. Lightly mark in guidelines, ensuring that they curve around the head as features are not flat on the face. Guidelines included here are for the eyes, the length of the nose and the mouth.

2 Try out different ways of holding the graphite stick – further back along the shaft of the stick or with your hand turned around so that the stick is cradled in your palm with the back of your hand against the paper. A broken line helps you to achieve greater accuracy and looks less obtrusive than a heavy single line. Try to look at the subject more often than your drawing – roughly 60 per cent looking and 40 per cent drawing. Begin defining the features. Note the shapes of the nostrils and top lip. Begin to erase the guidelines as you work.

3 Use the measuring technique described in Demonstration 1 (see page 20) to help you check distances between features. Draw the abstract shapes you see rather than acknowledging the features, to help you to be more objective. For instance, draw the shape between the chin and mouth and between the eyes and eyebrows. Observe the shapes of the whites of the eyes carefully to help determine the correct likeness of the entire eyes. Begin to draw the approximate details in the clothing.

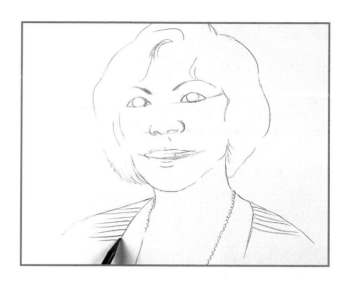

4 Although there are some expression lines on this face, don't mark them in too strongly or you will make the face look older than it is. Whilst you want to be true to life, you don't want to insult your subject! Draw some of the expression lines softly, with gentle pressure and blend them into the face. Some expression lines add to the character of the face and emphasize the personality. Begin to indicate the hair with some lines drawn in the direction of growth. Draw the shapes of the nostrils and some lines on the clothes.

5 Check the length and shape of the neck and note in more detail how the hair grows and frames the head. Using short, light strokes, put in some more of these details. Still using the 2B graphite stick, squint your eyes at the subject and sketch in the areas of the face that show up as shadow or darkest tones. Block in the darkest areas quickly and loosely using the 4B graphite stick. Keep a light touch at all times. If you over-shade, lift out some overly dark tones with the kneaded eraser, by pressing and lifting, not rubbing.

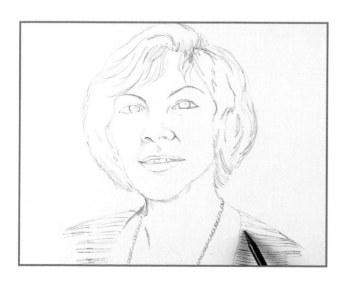

6 Shade the far side of the nose, under the hair and under the chin. Draw in more hair lightly. Add some gentle shading to the corners of the mouth. Graphite sticks are blacker and smudge more easily than pencil. Once you get used to this, take advantage of their dark, smudgy qualities and build up depth of tone. Vary the pressure on the graphite stick when moving from dark to light tones and leave the paper clean to show highlights. Be careful with the pupil and iris. Add a light shadow under the upper eyelid – actually on the eyeball.

7 Draw the eyebrows in the direction they are growing. Some eyebrows are very arched; others are flatter and straighter. These are light and feathery. Eyelashes are not too clearly defined but the eyes are outlined in black eyeliner. Try to get the shapes right here. Include the eyelid crease. Add more details to the hair and shade the lips. Notice the depth of tone around the teeth, the little shadows in the corners of the mouth and even paler tones on the skin around the mouth and nose.

Artist's tip
Look at the shape of the nostrils. Depending on your viewpoint, the nostrils will appear as different shapes and will affect the portrait.

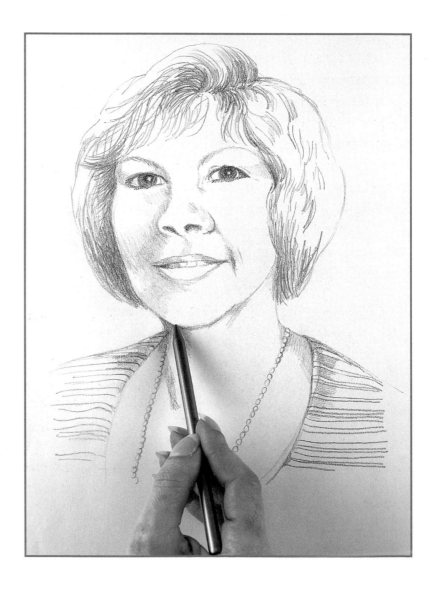

TRY A DIFFERENT ...

... MEDIUM

This portrait was drawn using a range of pencils. Using a 2B pencil, mark in the general outline and feature positions. Begin adding details such as the hair and neckline. Keep shifting your gaze from the subject to your drawing and back again. Draw in more details and begin building up the darkest tones. Lightly shade the lips, nostrils, around the eyes and in the hair. Use a 4B pencil to deepen the tones in the nostrils, the hair and the eyes. Deepen some of these tones even more where necessary, with the 6B

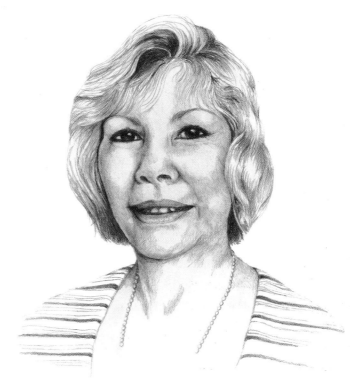

pencil, keeping the overall balance. Leave clean paper showing through for the brightest highlights. Develop the skin tones with soft, continual shading or a combination of hatched, stippled and cross-hatched marks.

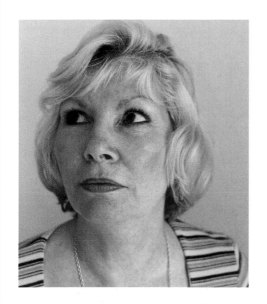

... POSE

Here the subject is looking up and away. This angle emphasizes the high cheekbones and shape of the head. If you are drawing this image from this angle, be aware of the line of the eyes and the mouth in particular. Remember that from this angle, the sitter's right cheek is smaller than her left cheek, which is closest to us. Also, the nose is pointing slightly towards the left of the picture (sitter's right). It's all a question of perspective, so ensure that you're not drawing any features straight on.

Demonstration 6

Dark-skinned Woman
Coloured pencils

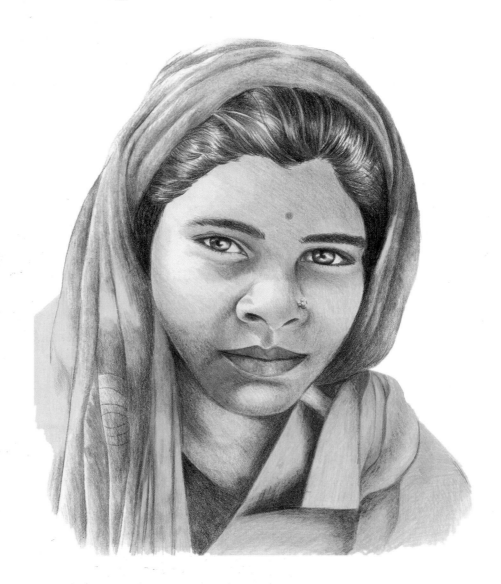

There are several ways to use coloured pencils to create the illusion of skin. You can blend colours, mixing them into different tones for the different planes of the face or you can burnish them. Burnishing takes more time than blending, so be patient. Blend the colours needed first and then use a lighter colour over the top to soften.

Local colour is the colour that generally describes something, e.g. grass is green. Two influences will change the local colour of skin; they are the colour of the light and colours in shadows and reflections. To start drawing a face, look for the local colour first and then try to see any coloured reflections and shadows.

If a person has yellow tones in his or her skin, he or she will probably have shades of violet in the shadows. Similarly, red or pink-toned skin might have green in the shadows. Brown or orange-toned skin will have blue tones in the shadows.

Try shading by layering colours one on top of the other. Use small, elliptical movements to cover the area completely or you could use light cross-hatching if you prefer. Don't press too hard, as you can add more layers for depth of colour.

Subject

The jewel-bright colours of her head-dress enhance the rich tones of this young woman's skin. As with all of the portraits in this book, the best way to begin is to view your subject in terms of shapes and shadows.

There are blue and violet tones in the shadows of her skin and some subtle reflections from the head-dress. By adding some of these unexpected colours, you will give your portrait a lift, but you really must be light-handed here or it could end up looking like war paint!

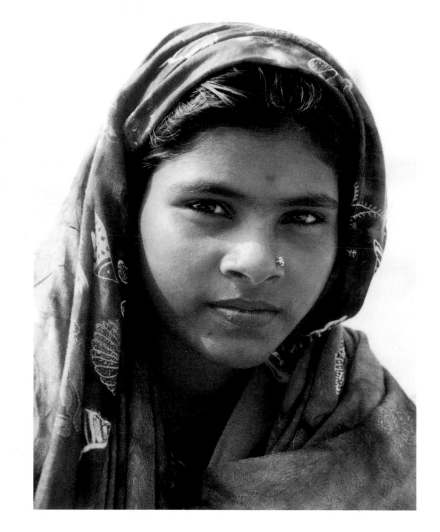

M **Materials**

2B pencil

Sheet of cartridge (drawing) paper 420 x 297mm (16½ x 11¾in)

Coloured pencils in several shades of yellow, brown, grey, pink and blue and one green and black

Plastic eraser

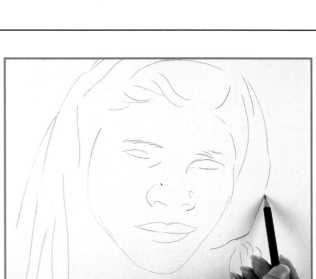

1 Visualize the shape of the head and shoulders on the paper. Ensure that your portrait will be large enough and don't leave too much space around the head or it will appear to "float" on the paper. Using the 2B pencil, lightly mark on rough guidelines for the head and shoulders. Make sure the shoulders are broad enough – a common mistake is to make the shoulders too narrow. Lightly draw guidelines for features, hair and head-dress.

2 Although faces are broadly symmetrical, even the most balanced features are irregular. Look out for any of these slight irregularities and establish the dimensions of the features and the spaces in between. Still using the 2B pencil, draw the shape of the face. Then mark in the features, remembering that the head is curved. Be aware of the bones and muscles that support and move the skin and hair (look back to page 15 for a recap). Continue to look at what you are drawing and don't let your subconscious interpret what you are seeing!

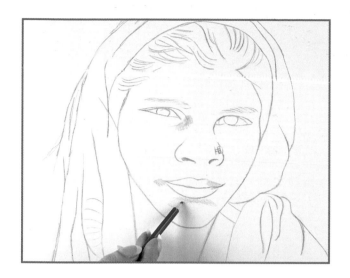

3 With a mid-brown pencil, go over the outlines of the face. Keep checking the subject to make sure that you are keeping to the correct proportions. Erase all pencil guidelines as you draw the face in coloured pencil. Use gentle pressure as you cannot erase coloured pencil easily, but you can always add more depth of colour later. Without smudging, change from dark to light tone through easing the pressure in the pencil. (Never smudge pencil or coloured pencil marks.)

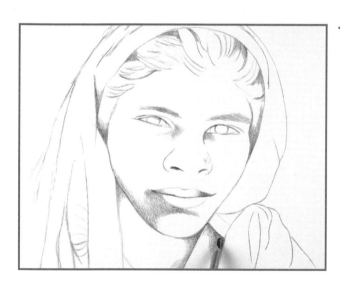

4 Add depth and definition with a darker brown or plum-coloured pencil. With gentle shading, add some dark yellow around the chin, cheeks and nose. Remember that the nose is essentially a wedge-shape; draw the shape of its base and the parts of the nostrils that you can see.

> ### Artist's tip
> For smooth tones, blend lightly and build up layers. Layers of different colours make interesting shades depending on the order in which they are applied.

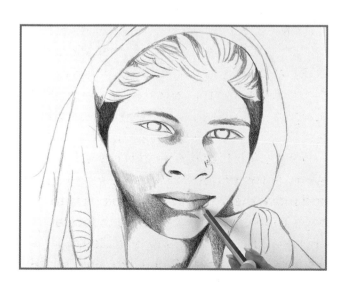

5 Using the darkest brown and black, continue to shade a little more strongly. Darken the nostrils and the shadows around the head-dress and the neck. It might be tempting, but try not to give the eyes too much attention early on or your portrait could become unbalanced. Use a touch of navy or grey in the nostrils and pupils, rather than black at this stage. Study the curve of the mouth and draw the inside line in dark brown, noting the curves and small shadows in the corners. Begin shading the hair.

6 Constantly move around the portrait comparing shapes and proportions. Shade the skin gently, using various tones of brown and yellow, squinting at the subject to see where to put the darkest and lightest tones. Shade the lips, noting that the top lip is slightly darker than the lower lip and there is some shading in the corners of the mouth. Add details, such as the reflected light on the eyes, showing highlights from two directions and from where and in what direction the eyelashes grow. Using the black pencil, flick the eyelashes with quick, sweeping motions. Colour the irises carefully with dark brown and black. Add grey or blue shadows under the chin and at the sides of the nose.

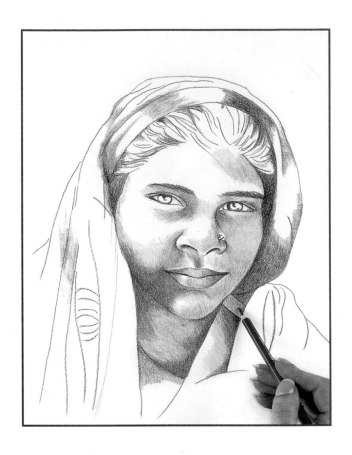

7 For the hair, draw in the general direction of growth, leaving the highlights and shading the deepest tones. Leave the paper where there are highlights or areas of shine. Aim for an overall "look" and don't try to include every hair, line and pore. Take some time over the features. For instance, create shadows cast on the whites of the eyes with pale blue. Draw the socket lines of the eyelid with grey and then deepen them with dark brown. The skin of the upper and lower eyelids can be seen between the eyes and eyelashes. Indicate this using a sharp pencil in mid-brown, with pale blue or light grey on the whites of the eyes. Continue to colour the clothes, noting where the fabric falls in folds and creates dark and light tones. Shade the darkest tones on the fabrics with brown, black, grey or dark blue.

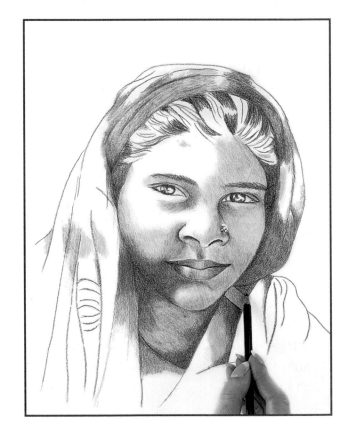

TRY A DIFFERENT ...

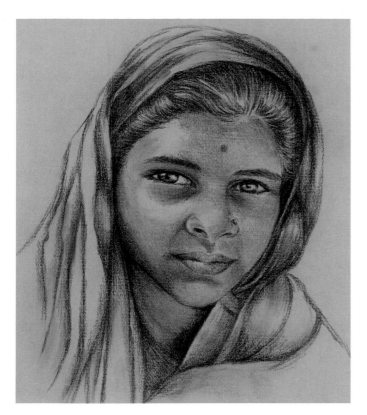

... MEDIUM

This portrait was drawn with Conté crayons on coloured Ingres paper. Begin as with the coloured pencil version and mark in the outlines of the face, hair and features with a sepia Conté crayon. Show the strong contrast between light and shade with the black and sanguine. Resist the temptation to draw a continuous outline, but use broken lines for the entire portrait. Keep cross-referencing the proportions and shapes you are looking at and remember to look at your subject more than you look at your drawing. Note the shapes of the eyes, as these can alter the character of the face. Draw the central line of the lips carefully and add the slight shadows at the corners of the mouth. Define the shape of the nose by drawing the base and adding tone to the sides – balance this with the darkest tones in the eyes and hair. Use both sanguine and sepia Conté crayons for mid-tones, blending carefully to leave no apparent lines.

... POSE

You might like to draw this subject smiling. The way the light falls on her face adds extra interest to the image. As ever, don't draw every tooth and don't leave either the teeth or whites of the eyes completely white – they both have a slight cast shadow. When you have drawn the basic outline, look for the deepest shadows and any informative lines and tones. Don't overdraw the lips – they need soft handling so they don't become too prominent in the portrait.

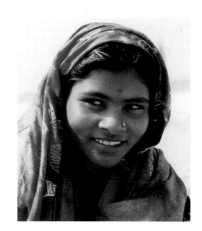

Demonstration 7

Child *Pen and ink*

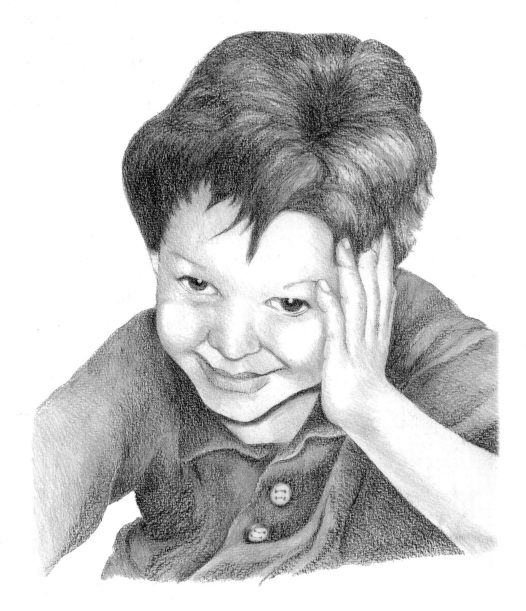

As discussed on pages 24-29, small children or babies rarely remain still for long, unless they are asleep, so you have to make the most of their activities. Keep your sketchbook handy for when they are watching television, playing with their friends, eating or sleeping. This is manageable if you have your own children, but if not, study pictures of children

in catalogues and magazines. They will give you valuable information about proportion, expressions and flexibility. If you have children in the family or friends with children, take some photos. Take several in different situations to give you an understanding of the way the child moves and expresses him or herself. Children's heads are large in relation to their body size. In comparison to adults, they have large eyes, narrow necks and small ears, mouths and noses. You will notice that their hands and shoulders appear small in comparison to their heads too.

You will not have to add as much tone to a child's portrait as you do for a portrait of an adult, but an interesting contrast can be an indication of texture on their clothing. Always try to keep the balance right, however. For example; a pale, fine-haired child should not be overpowered with overworked clothes.

Subject

Whether you are drawing from a child sitting or standing in front of you, from a photograph or from a series of sketches, the final portrait should look natural and relaxed. Try directing light from an angle rather than straight on to the face. If you are drawing from a live model, whether a young child or an adolescent, be aware that they will probably be either bored easily or fairly self-conscious, so give them something to do. A comfortable pose is essential. This cheeky little boy was posing quite naturally with his head resting on his hand, creating a composition that leads the viewer's eye into and around the portrait.

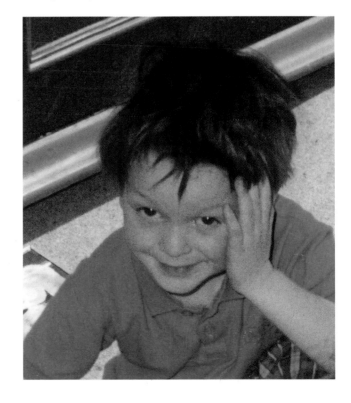

Materials

2B pencil

Sheet of coloured, textured pastel paper 420 x 297mm (16½ x 11¾in)

Mechanical pen (.01)

Plastic eraser

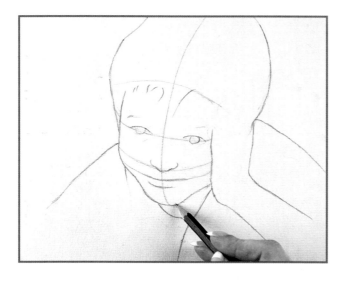

1 Study the subject, concentrating on the negative shapes around the outline. Visualize this on your paper and lightly draw it in pencil. Add light guidelines to position the features. Note the shapes between features and in comparison to each other. It is those shapes that will give you a good likeness. Particularly note the shapes between the nose and lips, between the eyes and brows and the whites of the eyes. Draw the centre line of the lip – usually the bottom of the top lip – as it appears.

2 Draw the outline of the face more carefully using broken lines. Erase the guidelines when you are happy with the position of everything and lightly outline the features. Mark in the neckline and the large overall shape of the hair. Never draw a definite line where the lip meets the face or you will instantly lose all authenticity. Begin to draw the finger shapes, always seeing them as just shapes, not fingers!

3 Draw the hair and neckline in a little more detail and complete the outline of the hand. Look for folds and creases in the clothes and mark them on with lines. Draw the buttons lightly and the collar of the T-shirt. Mark in small circles where you'll show highlights in the eyes and always draw the eyebrows lighter than they actually are.

4 If you hold the portrait up to a mirror any errors or inaccuracies will show up immediately. Adjust any details, such as the buttons and folds in the T-shirt. Tidy up the outline of the hair. Start to add depth to the iris and pupil, ensuring that you don't touch the highlight. You can shade the iris with radiating lines, stippling or cross-hatching.

5 Now take the pen and, using broken lines, pick out some of the darkest toned areas, such as the base of the nose, pupils and areas around the chin and hairline. Use short, broken lines for the darkest parts of the hair. Never use a heavy continuous line with the pen. Continuous lines, especially in pen, tend to make portraits look flat and cartoon-like. Children have few facial lines, so be careful not to be too heavy-handed. With an extra light touch, draw lots of quick little lines to make the tones as smooth as possible. These can be made stronger if necessary by adding to them later. Indicate more creases in the T-shirt with some short, broken lines to add movement to your picture.

Artist's tip
Use the pencil in different ways to describe various parts of the image. For instance, use hatching to fill in large areas of tone and stippling for smaller areas, such as on the face.

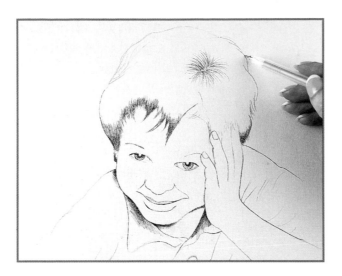

6 Continue using small broken lines over your pencil lines and – to add tone to the portrait – under the chin, around the hair and so on. Half-close your eyes and squint at the subject to help to define the darkest areas. For the hair, hold the pen quite high and keep the ink flowing. Build up details carefully all over, trying not to concentrate on any one area too much.

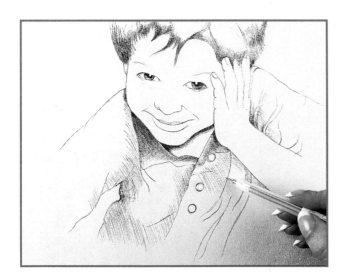

7 Darken the deepest tonal areas, constantly moving about the portrait, drawing and redrawing shapes more accurately and generally keeping the balance between tones and shapes. For tone, use a mixture of hatching, cross-hatching and stippling, or just one of these techniques. Add more details to the features and T-shirt, never using a solid outline around any of the features. Keep everything light and subtle. Remember that the eyeball is a sphere and so highlights and shadows are always curved.

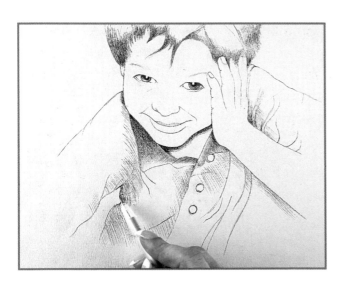

8 Continue working around the portrait, keeping a balance of tones and detail. Don't overdo it! Use a light touch – you can always add more later. Shade the hair using light dashes. For soft edges, flick the pen so that it hardly touches the paper. Practise blending like this in your sketchbook, it becomes easy after a short time. Overlay short dashed lines on to others to get a rich, dark tone, such as on the collar or in the hair. When the ink is dry, erase any remaining pencil marks gently, using an eraser.

TRY A DIFFERENT ...

... MEDIUM

For this pencil portrait, use the measuring technique explained in Demonstration 1 (see page 20) and mark on the outline, plus proportions and shapes of the features. Add details, such as the mouth, the base of the nose and the eyes and mark in some of the darker tones of the hair. Use a 4B pencil for the darkest areas and a 2B and HB for the lighter areas. Shading should be smooth with a gentle gradation from dark to light. You might need a plastic or kneaded eraser to correct any slight mistakes or to lift out heavy tones. Gently shade between the fingers, under the chin and around the mouth and eyes.

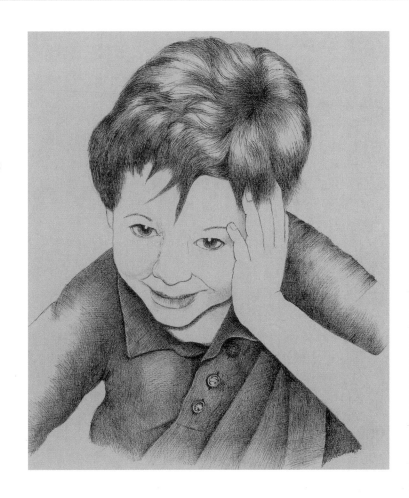

... POSE

Try drawing this photo of the same little boy. A portrait of a memorable moment in a child's life, such as a first day at a new school, will be treasured for many years. Don't forget to view the face objectively – draw only what you see, not what you think you see.

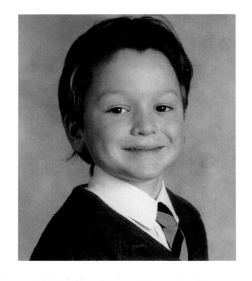

Demonstration 8

Man *Dip pen and ink*

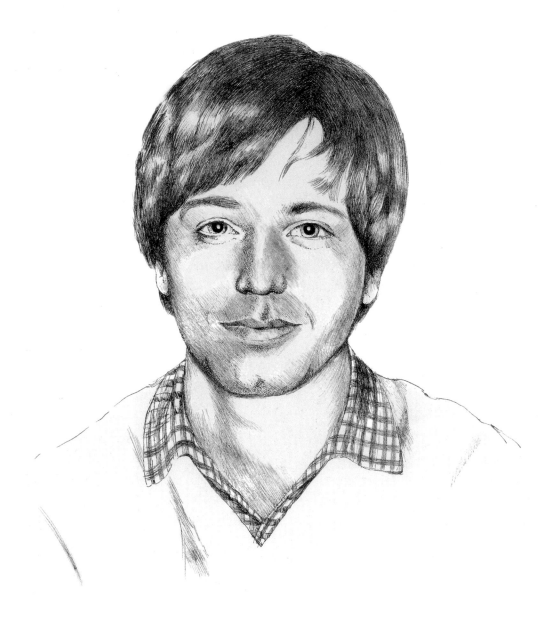

Men have different proportions, shapes and even tones in comparison to women. One of the main differences is the length and shape of the jaw. Another difference is the lips; in general, men's mouths are not as deeply coloured as women's are. Many women wear eye make-up, whereas few men indulge in eyeliner, so go carefully. Also, men have

heavier eyebrows, but fewer eyelashes. Remember to really look at your subject and not to draw the symbols in your head of what you think faces look like. It really pays to be as objective as you can – whoever you are drawing. Another common error is to make clothing seem as if it is part of the body, when usually it is fairly loose on the skin. Ensure that you draw collars slightly larger than the neck and that you can see the shape of the cloth on the shoulders, over the arms and under the armpits. It's easy to forget these things and end up with superhero-type "sprayed-on" clothes.

Subject

This portrait was lit from slightly above the subject. He was relaxed for the drawing, so the completed image does not come across as too formal or contrived. Note where the highlights fall in the centre of the eyes and how the bottoms of the ears are pale where the light catches them. This is a classically lit portrait – the top lip appears darker than the bottom lip and there is a darker line of shadow under the chin.

For this portrait, there is an enigmatic smile to capture, indicated by the smiling eyes and light lines around the mouth. Try not to over-emphasize any one particular feature or you could end up with a caricature rather than a sensitive portrait.

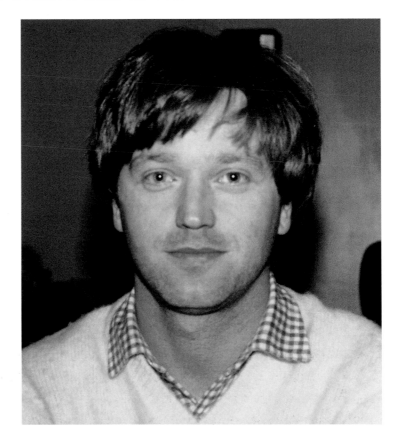

✐ Materials

2B pencil

*Sheet of cartridge
(drawing) paper 420 x
297mm (16½ x 11¾in)*

Dip pen

Indian ink

White ink

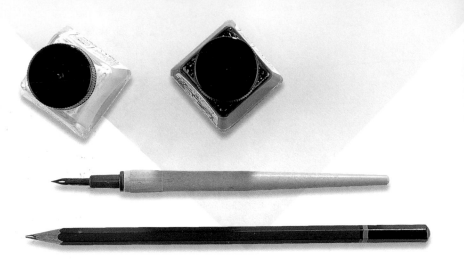

1 Direct your gaze at the negative space around the subject's head and shoulders and see him as an empty shape within it. Look back at your drawing paper and visualize that shape on it. With the pencil, draw the outline of this shape to anchor the portrait in place for your composition. Within the outline of the head and shoulders, add guidelines to place the approximate positions of the eyes, base of nose, mouth and bottom of the ears. Remember, the head is curved so everything curves accordingly.

2 Check angles and dimensions – what are the relationships between the nose and the mouth and between the chin and the neckline? What shape is between the two eyebrows? Begin to lightly sketch in these shapes. Draw the curve of the upper eyelids, a little bit of collar and the central line of the lips.

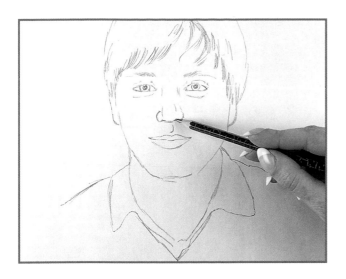

3 Start to draw some lines to indicate the hair. Continue to check the shapes and measurements of the face and gradually build up the shapes of the features, such as the ears, eyes and base of the nose. If you want to, use the measuring technique described in Demonstration 1 (see page 20). Check the shapes and proportions over and again, to ensure that everything is as accurate as possible.

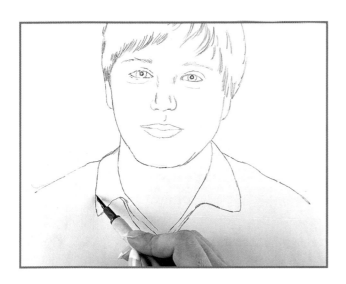

4 When you're quite happy with the features, change to the dip pen. Dip the pen into the ink and wipe the nib on the side of the ink bottle. (Keep a piece of cloth or kitchen towel at hand in case of any mishaps.) Go over your drawing with broken lines, rather than solid lines. This gives you control over the image, helps you to refine the picture as you go and gives a softer appearance. Erase pencil lines as you replace them with ink. Build the hair up with a series of lines drawn in the direction of growth.

5 Draw the shapes of the whites of the eyes rather than the outline of the eyes. By concentrating on the whites you will eliminate your subjective image of eyes. Begin to draw the shapes of the eyebrows using small, quick strokes in the direction of growth. Lashes should also be drawn with light, quick flicks of the pen in the direction of growth. Use fewer strokes than you would for a woman's eyes. Begin marking on the pattern of the collar.

6 Stipple around the nose – never draw lines on either side of the nose, but use soft tones as you see them. In this case, you could use stippling or hatching. The nose is the most prominent feature of the human head. It is often seen with light on one side and darkness on the other. If you squint your eyes, along with the pupils and the inside line of the mouth, the base of the nose and nostrils are the darkest parts of the face. Add more hair and collar pattern.

7 Pen and ink can't show gradations of solid tone, so stippling, hatching or cross-hatching are the only ways to show nuances of shade. Use a light touch and fairly quick movements to prevent the ink from blotting. Facial muscles form the individual appearance of our expressions and it has been discovered that our first language shapes our habitual facial movements. In other words, the shapes of our features are determined not only by genetics, but also by the words we speak.

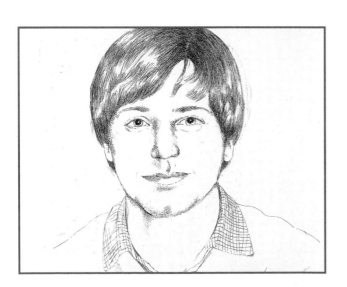

8 Continue shading the hair. Constantly refer to your subject, re-establishing proportions and shapes and ensuring that the face is developing correctly. Be light-handed with the pen at all times as you can always add more, but you can't take any away. Add some more clothing details and add white ink where necessary to soften some of the edges. You don't have to include the white ink, but when layered over the black, it creates a mid-tone which can bring a further dimension to a pen and ink portrait.

TRY A DIFFERENT ...

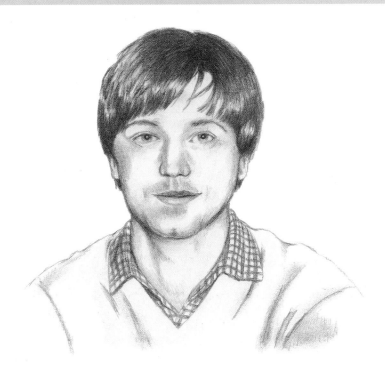

... MEDIUM

This version of the portrait was drawn in charcoal. Charcoal stick was used for the main marks and details were added with charcoal pencil. Start with a few light marks for the outline of the head and shoulders and some guidelines for the features. Look objectively at the features – draw them as a series of lines and shapes then begin drawing tones in the hair, the eyes, around the chin and the nose. To blend tones, use a torchon, your finger or a cotton bud. Let the white paper show through for the highlights.

... POSE

An alternative pose such as this one, where the subject is looking away from you, can be as enjoyable to draw and as pleasing to the subject as a classic pose. As with the Mature Woman (see pages 42–47), this face is turning away and so the subtleties of perspective are needed. The lips, for example, are not straight on, but the side that is furthest away from our view appears to recede or become smaller. Don't forget that the face is neither flat nor totally rounded.

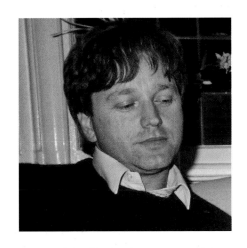

Demonstration 9

Woman *Conté crayons and sticks*

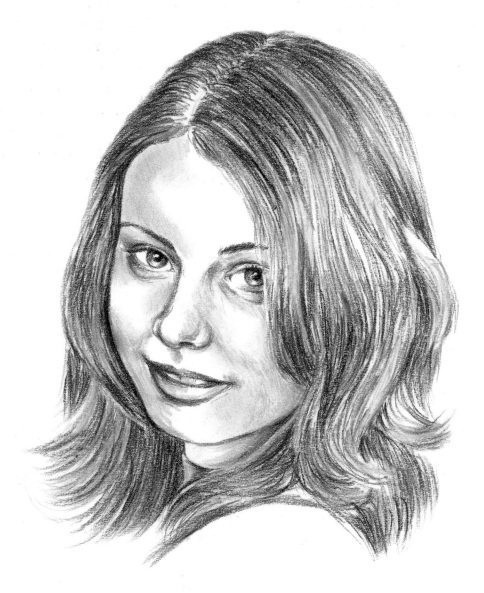

Good drawing skills result from patient observation and lots of practise. Once you have acquired an understanding of the basic structure of the head and features, you will find it easier to get the proportions right.

Practise sketching people's heads from different angles, to improve your skills and develop your confidence.

Be aware of how features change to create different expressions and reflect emotions.

When happy, all the facial features lift; when downhearted, they appear to drop; when relaxed, they look softer. One of the reasons that the Mona Lisa's smile seems strange to us is because her mouth is smiling but her eyes are not. This is quite unusual – look at any smiling face and see how the eyes crinkle. This crinkling can develop into crows' feet as we mature, just as frequent squinting or frowning can cause permanent wrinkle lines on the bridge of the nose between the eyes.

This portrait has been drawn with Conté crayons and sticks. They have a slightly rougher feel than pencils, so you might want to try out a few scribbles in your sketchbook first. Most of this portrait is simply a general impression, not a detailed study. This gives a fresher final result – it is descriptive without being heavy. Do not overwork the Conté by rubbing it too much. Most of the definition of the features relies on the fall of light and shadow, so keep squinting at the model to see exactly where this lies.

Subject

This woman is sitting in a more formal pose than most of the other models we've already looked at. Notice how the eyes and mouth in particular give away the person's mood. The stance of the body can also tell us a great deal.

The idea of drawing someone looking over their shoulder – back at the artist – is a classical one and has been used in many famous portraits. Before you start though, watch out for the slight angle and perspective of the features – the receding half of the face does appear to be smaller than the side of the face that is closest to us.

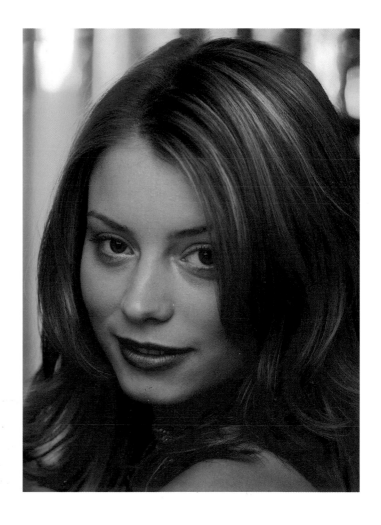

Materials

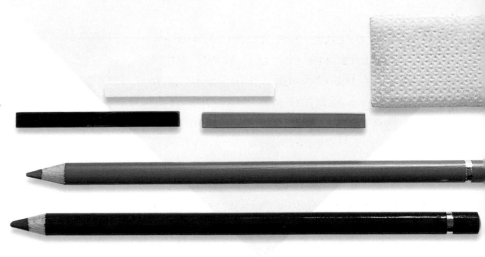

*Conté sticks and crayons
in black, sanguine, sepia,
beige, grey and white*

*Sheet of cartridge
(drawing) paper 420 x
297mm (16½ x 11¾in)*

Kneaded eraser

Fixative

1 Begin by studying the person carefully. Envisage the outline of her head as a negative space. On the paper, visualize the shape of this outline and then, with the sanguine Conté crayon, lightly mark it in, adding some guidelines for the features. A few light lines, showing the angle of the hair, the shape of the chin and what can be seen of the neck and the approximate position of the mouth is enough.

2 Put aside thoughts of proportions, measurements and what you know about faces. Look completely objectively. Concentrate only on line for now – what is the shape of the base of the nose to the sides of the mouth? What is the shape of the chin and jaw? Draw these in lightly. It doesn't matter where you begin, but keep moving around the face to ensure that you don't put too much emphasis on one particular area.

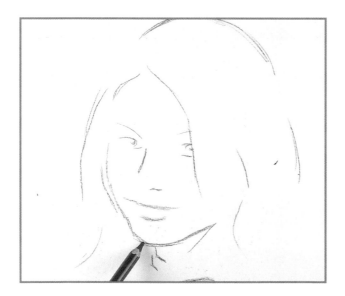

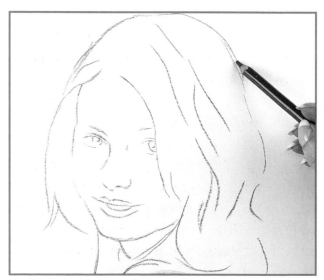

3 Still using soft strokes, begin to firm up the features. The eyes and mouth are important to the character of the portrait so study them carefully. Draw the centre lip line before you fill in details of the lips. Notice that this line is often asymmetrical and the thickness of the line may vary. When you have drawn this line, look for the shadow that often appears below the lower lip. Begin to add shape to the eyes and directional lines to the hair. If you draw anything too heavily, soften it with a kneaded eraser.

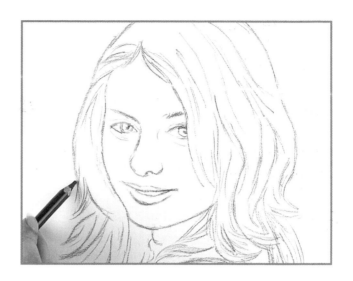

4 Using the black Conté stick, add deeper tones and lines to the hair, the corners of the mouth and the eyes. Notice the shape of the whites of the eyes, the lids and the curves under the eyes. Ensure that you have the mouth "right" as it is at an angle to the rest of the face, so appears to be slightly distorted. Hair should always be indicated with lines in the direction of growth – and this goes for eyebrows and eyelashes too. If any part of the portrait is becoming too heavy, lift the Conté with a kneaded eraser.

5 Now use the sepia Conté stick to add further tones and shadows to the image. Deepen the eyebrows and under the chin as well as in the hair. Take care to use gentle lines or they could look artificial and make your portrait look more like a cartoon. Always leave highlights in the eyes, even if you cannot see them, as this makes the eyes more realistic and alive. Remember that the eyes are recessed into the eye sockets. Add some light shading to the base of the nose and the top lip.

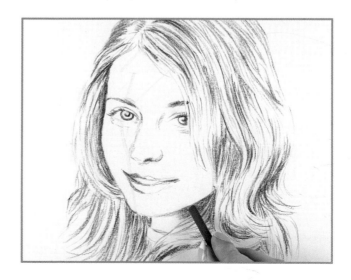

Artist's tip

With Conté, pastel or chalk, you should be prepared to stop work on the image before you think you've finished. You should leave some of the surface you are working on showing through. This is the style of Conté and pastel – you only have to see some of the works by da Vinci or Toulouse-Lautrec to see how the ground becomes an important part of the image.

7 The pupils come directly above the corners of the mouth. Deepen the eyebrows. These are features with firm edges, but other areas on the face have soft edges. With Conté you can smudge these edges using your finger or a torchon or layer other colours on top of earlier ones. For the hair, show the lights and darks by layering various shades as the light falls on it – nobody's hair is one flat colour all over. Squint your eyes at your model to see the darks and lights more clearly and use hatched lines in the direction of growth. Spray the finished drawing with fixative.

6 The nose can be difficult to draw because it does not have exact edges that can be represented by lines. Noses are defined only by the change in contour as the skin moves over the bone and cartilage. Only the nostrils have an exact shape that can be studied and drawn. Look for the side that has the greatest shadow and draw the shape of that shadow. The shadow that defines the nose usually connects to the shadow above the eye in the eye socket area. Add a little light brown and white Conté to bring out the image to make it more three-dimensional. Try not to be heavy-handed with any of the Conté sticks or crayons, you can always add more later.

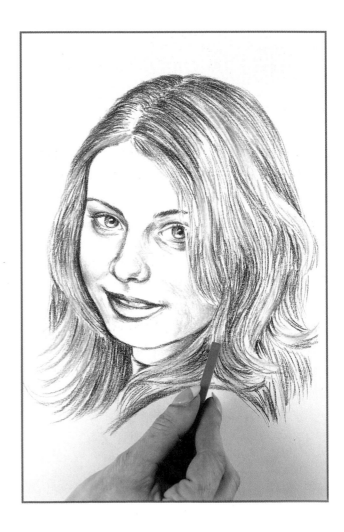

TRY A DIFFERENT ...

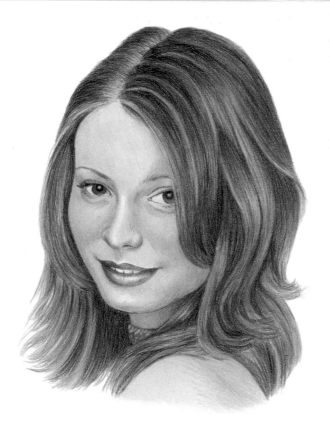

... MEDIUM

This portrait was drawn lightly with a brown pencil and then layers of colour were built up and blended carefully to create the various skin and hair tones. Areas of paper have been left to indicate highlights. Note how many highlights there are – in the eyes, on the nose and cheeks. Then look for the darkest areas – around the nose, between the lips, in the eye sockets and so on. Create them with any combination of your darkest shades of brown, blue or grey, mixed with yellow ochre, orange or raw umber. This look was achieved by layering colours on top of each other, so don't be afraid to experiment. There are several different shades making up the skin and hair tones and several different types of pencil were used, so feel free to mix! Try to get used to working with sharp pencils, whether coloured pencils or graphite, and try out different types and makes to see which ones suit you best.

... POSE

Try drawing this model in this alternative pose – use the same method of looking for the negative shapes around the head and the shapes of the shadows as you start, then continue with the darkest and lightest tonal shapes.

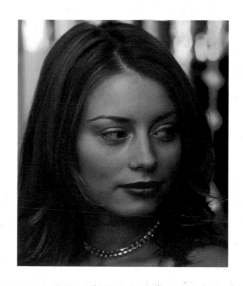

Demonstration 10

Group *Pencil*

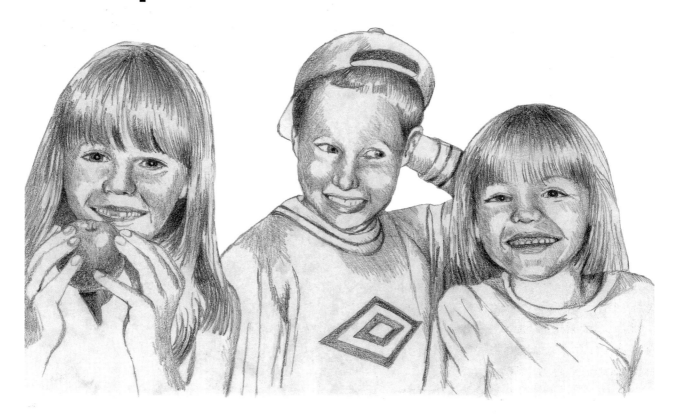

Once you have gained some experience in portraiture you might find that you are in demand! Don't be surprised if you are asked to draw a group of people rather than an individual. Often couples, families or groups of friends want to be depicted together to show a moment in time. Commemorative portraiture has been popular since the time of the ancient Romans and is as popular as ever two thousand years later.

Remember that no matter what you are drawing, the composition must be effective.

When drawing a group, visualize them all as one particular shape, then imagine how viewers' eyes will be drawn around the picture. Is there any one person or object that blocks the flow as you look around the group? Is there any person or object that dominates the whole group and is there anything that affects the harmony of the scene? Try out different poses until you find one that you are happy with. Whether it's a formal or informal group, find a pose that is relaxed, but also animated and interesting.

Decide on your eye level. Will you be above, below or on the same level as the people you are drawing? Will looking up or down affect the mood of the drawing? Keep the background simple and never have too strong a light on the group. There are no secrets to drawing a group portrait successfully; you simply have to make methodical judgements. Even if your first judgements turn out to be wrong, you will have learned what not to do next time! It's a good idea to draw some thumbnail sketches, indicating where you will place each person in your picture.

Subject

Drawing a group of people needs more planning than a single portrait. This group has what most good compositions require – contrast and balance, there are spaces between the subjects and they also overlap each other, there is a variation in their heights and in the distances between their heads, all of which adds interest. The most important decisions to make here are how much of the children to include and the overall shape of the group. You need to view them as a whole in terms of negative shapes, so note such things as the triangular shape between the boy's arm and the rounded shapes of the girls' heads. Incidentally, it can be helpful to draw people individually before you draw them as a group.

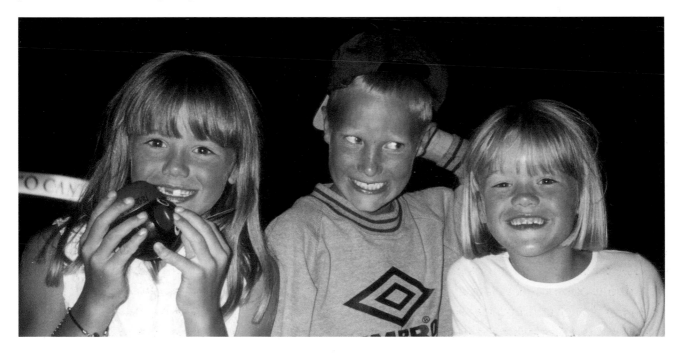

Materials

2B, 3B, 4B and 6B pencils

Sheet of cartridge (drawing) paper 210 x 297mm (8¼ x 11¾in)

Kneaded eraser

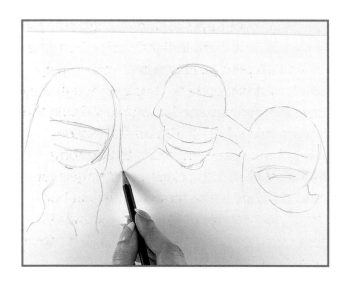

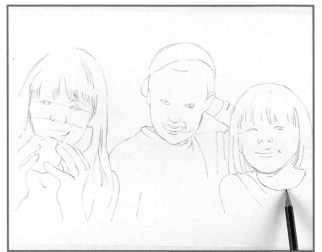

1 Mark in the main negative shapes of the heads and shoulders with a 2B pencil. Measure and mark on some guidelines – for the eyes, the bases of noses and levels of lips. Look all the time for outline shapes, such as between the heads and shoulders and the general shapes of the hair.

2 Decide if there are things about the subjects that you might not want to include or change – you can use artistic licence! For example, one little girl is holding an object, which I have changed to an apple. Check that the spaces between the children look right. Still focussing only on shapes, roughly draw the jaws, mouths and eyes. Put a few light creases in the clothes. Always use broken lines rather than hard, solid lines. Erase guidelines as you work.

3 Look for the different shapes of the children's eyes. Although the girls' eyes are similar, they are not identical. These variations will help your picture to become "real". Notice how much of the eyelid is visible and the different shapes of the whites of the eyes. Also, see how the eyes change shape according to the angle of the head. Draw the mouths in lightly and mark in a few teeth, but not in too much detail. Add more detail to the necklines. Always keep your hand back from the point of the pencil.

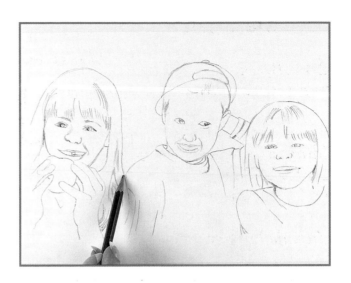

4 Squint your eyes to find the darkest areas and mark them in lightly using both the 3B and 4B pencils. Ensure that each top lip retains its characteristic shape, although they have all been flattened into smiles. Some top lips are thin whilst others are full. Shade around the noses and begin to add some more details; on the clothes and fingers for example. Add some tones to the hair, but don't worry about too many details at this stage. Keep checking all shapes and shadows across the whole portrait.

5 Gradually build up the tones, continually checking the shapes and tones in relation to each other. Use the measuring technique described in Demonstration 1 (see page 20) to ensure that you have the correct proportions. With a light touch, draw lines in the hair to show tones. Mark the pupils with more depth, leaving some of the paper clean for highlights. This is where you begin to make the skin look three-dimensional. Carefully and lightly shade darker parts of the cheeks and chin.

6 Continue shading all of the children's faces and hair. If you shade too much, lift out the pencil marks with a kneaded eraser. Soften crease lines on the clothes with careful shading. Double check where the necklines fall in relation to the heads. For example, the girls' necks are more visible than the boy's as he has his head tilted. Add details to his cap and to the apple. (You might want to look at an apple to see how to shade it).

7 Build up the darkest tones with the 6B pencil. Give the general idea of the hair with further hatching lines, leaving some areas with paper showing through to indicate shine. If you over-shade, flatten the kneaded eraser into a chisel shape and either press and lift it, or stroke it in the direction of hair growth.

Artist's tip

Remember that a head is a series of planes and light falling on the head reveals surfaces and angles, so note the direction of light and the way that some areas are lit and some are in shadow.

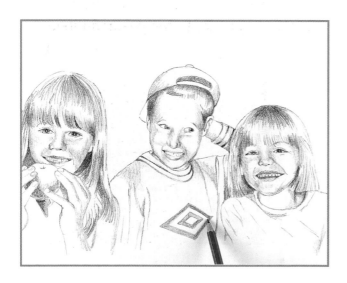

8 Increase the depth of the dark areas with the 6B pencil. Do not overdo the eyes – they are rarely as large as you think. Lightly go over the teeth, drawing only the general shapes you see, not every single tooth. Avoid putting too much detail in the clothing; simply indicate some folds and creases.

TRY A DIFFERENT ...

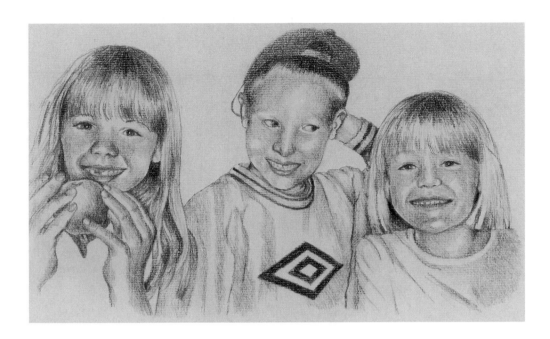

... MEDIUM

I drew the same group using graphite sticks. Roughly mark some outlines with a 2B graphite stick. Draw the negative shapes of the children by comparing sizes and distances as before. Gradually build up details of all the features. As you work, keep moving across the whole group, never concentrating for too long on any one person. You need to keep the whole portrait balanced. Even if you don't think you have got the exact likeness, start to add light tones across the faces. This might surprise you, but often the tones make portraits look realistic. Check that the proportions are correct and change to the softer graphite sticks for deeper tones. Graphite sticks are easily smudged, so spray your finished portrait with fixative.

... POSE

Try out a full-length portrait from a holiday snapshot. You could make the children bigger and lessen the importance of the background for a truly memorable group portrait.

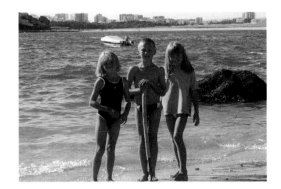

Suppliers

UK

Cass Arts
13 Charing Cross Road
London WC2H 0EP
Tel: (020) 7930 9940
&
220 Kensington High Street
London W8 7RG
Tel: (020) 7937 6506
Website: www.cass-arts.co.uk
Art supplies and materials

L Cornelissen & Son Ltd
105 Great Russell Street
London WC1B 3RY
Tel: (020) 7636 1045
&
1a Hercules Street
London N7 6AT
Tel: (020) 7281 8870
General art supplies

Cowling and Wilcox Ltd
26-28 Broadwick Street
London W1V 1FG
Tel: (020) 7734 9558
Website: www.cowlingandwilcox.com
General art supplies

Daler-Rowney Art Store
12 Percy Street
Tottenham Court Road
London W1A 2BP
Tel: (020) 7636 8241
Painting and drawing materials

Daler-Rowney Ltd
PO Box 10
Southern Industrial Estate
Bracknell
Berkshire RG12 8ST
Tel: (01344) 424621
Website: www.daler-rowney.com
Painting and drawing materials
Phone for nearest retailer

T N Lawrence & Son Ltd
208 Portland Road
Hove BN3 5QT
Shop tel: (01273) 260280
Order line: (01273) 260260
Website: www.lawrence.co.uk
Wide range of art materials
Mail order brochure available

John Mathieson & Co
48 Frederick Street
Edinburgh EH2 1EX
Tel: (0131) 225 6798
General art supplies and gallery

Russell & Chapple Ltd
68 Drury Lane
London WC2B 5SP
Tel: (020) 7836 7521
Art supplies

The Two Rivers Paper Company
Pitt Mill
Roadwater
Watchet
Somerset TA23 0QS
Tel: (01984) 641028
Hand-crafted papers and board

Winsor & Newton Ltd
Whitefriars Avenue
Wealdstone
Harrow
Middlesex HA3 5RH
Tel: (020) 8424 3200
Website: www.winsornewton.com
Painting and drawing materials
Phone for nearest retailer

SOUTH AFRICA

CAPE TOWN
Artes
3 Aylesbury Street
Bellville 7530
Tel: (021) 957 4525
Fax: (021) 957 4507

GEORGE
Art, Crafts and Hobbies
72 Hibernia Street
George 6529
Tel/fax: (044) 874 1337

PORT ELIZABETH
Bowker Arts and Crafts
52 4th Avenue
Newton Park
Port Elizabeth 6001
Tel: (041) 365 2487
Fax: (041) 365 5306

JOHANNESBURG
Art Shop
140ª Victoria Avenue
Benoni West 1503
Tel/fax: (011) 421 1030

East Rand Mall Stationery and Art
Shop 140
East Rand Mall 1459
Tel: (011) 823 1688
Fax: (011) 823 3283

PIETERMARITZBURG
Art, Stock and Barrel
Shop 44, Parklane Centre
12 Commercial Road
Pietermaritzburg 3201
Tel: (033) 342 1026
Fax: (033) 342 1025

DURBAN
Pen and Art
Shop 148, The Pavillion
Westville 3630
Tel: (031) 265 0250
Fax: (031) 265 0251

BLOEMFONTEIN
L&P Stationary and Art
141 Zastron Street
Westdene
Bloemfontein 9301
Tel: (051) 430 1085
Fax: (051) 4304102

PRETORIA
Centurion Kuns
Shop 45, Eldoraigne Shopping Mall
Saxby Road
Eldoraigne 0157
Tel/fax: (012) 654 0449

AUSTRALIA

NSW
Eckersley's Art, Crafts and Imagination
93 York St
SYDNEY NSW 2000
Tel: (02) 9299 4151
Fax: (02) 9290 1169

Eckersley's Art, Crafts and Imagination
88 Walker St
NORTH SYDNEY NSW 2060
Tel: (02) 9957 5678
Fax: (02) 9957 5685

Eckersley's Art, Crafts and Imagination
21 Atchinson St
ST LEONARDS NSW 2065
Tel: (02) 9439 4944
Fax: (02) 9906 1632

Eckersley's Art, Crafts and Imagination
2-8 Phillip St
PARRAMATTA NSW 2150
Tel: (02) 9893 9191 or
1800 227 116 (toll free number)
Fax: (02) 9893 9550

Eckersley's Art, Crafts and Imagination
51 Parry St
NEWCASTLE NSW 2300
Tel: (02) 4929 3423 or
1800 045 631 (toll Free number)
Fax: (02) 4929 6901

VIC
Eckersley's Art, Crafts and Imagination
97 Franklin St
MELBOURNE VIC 3000
Tel: (03) 9663 6799
Fax: (03) 9663 6721

Eckersley's Art, Crafts and Imagination
116-126 Commercial Rd
PRAHRAN VIC 3181
Tel: (03) 9510 1418 or
1800 808 033 (toll free number)
Fax: (03) 9510 5127

SA
Eckersley's Art, Crafts and Imagination
21-27 Frome St
ADELAIDE SA 5000
Tel: (08) 8223 4155 or
1800 809 266 (toll free number)
Fax: (08) 8232 1879

QLD
Eckersley's Art, Crafts and Imagination
91-93 Edward St
BRISBANE QLD 4000
Tel: (07) 3221 4866 or
1800 807 569 (toll free number)
Fax: (07) 3221 8907

NT
Jackson's Drawing Supplies Pty Ltd
7 Parap Place
PARAP NT 0820
Tel: (08) 8981 2779
Fax: (08) 8981 2017

WA
Jackson's Drawing Supplies Pty Ltd
24 Queen St
BUSSELTON WA 6280
Tel/Fax: (08) 9754 2188

Jackson's Drawing Supplies Pty Ltd
Westgate Mall, Point St
FREEMANTLE WA 6160
Tel: (08) 9335 5062
Fax: (08) 9433 3512

Jackson's Drawing Supplies Pty Ltd
108 Beaufort St
NORTHBRIDGE WA 6003
Tel: (08) 9328 8880
Fax: (08) 9328 6238

Jackson's Drawing Supplies Pty Ltd
Shop 14, Shafto Lane
876-878 Hay St
PERTH WA 6000
Tel: (08) 9321 8707

Jackson's Drawing Supplies Pty Ltd
103 Rokeby Rd
SUBIACO WA 6008
Tel: (08) 9381 2700
Fax: (08) 9381 2525

NEW ZEALAND

AUCKLAND
Draw-Art Supplies Ltd
5 Mahunga Drive
Mangere
Tel: (09) 636 4986
Fax: (09) 634 5162

The French Art Shop
33 Ponsonby Road
Ponsonby
Tel: (09) 376 0610
Fax: (09) 376 0602
Studio Art Supplies
81 Parnell Rise
Parnell
Tel: (09) 377 0302
Fax: (09) 377 7657

Gordon Harris Art Supplies
4 Gillies Ave
Newmarket
Tel: (09) 520 4466
Fax: (09) 520 0880
&
31 Symonds St
Auckland Central
Tel: (09) 377 9992

Design Art Supplies
Atrium on Elliot
Auckland Central
Tel: (09) 303 3177

WELLINGTON
Websters
44 Manners Street
Tel: (04) 384 2134
Fax: (04) 384 2968

Affordable Art
10 McLean Street
Paraparaumu\
Tel/Fax: (04) 902 9900

Littlejohns
170 Victoria Street
Tel: (04) 385 2099
Fax: (04) 385 2090

CHRISTCHURCH
Fine Art Papers
200 Madras Street
Tel: (03) 379 4410
Fax: (03) 379 4443

Brush & Palette
50 Lichfield Street
Christchurch
Tel/Fax: (03) 366 3088

DUNEDIN
Art Zone
57 Hanover St
Tel/Fax: (03) 477 0211

Index